Contents

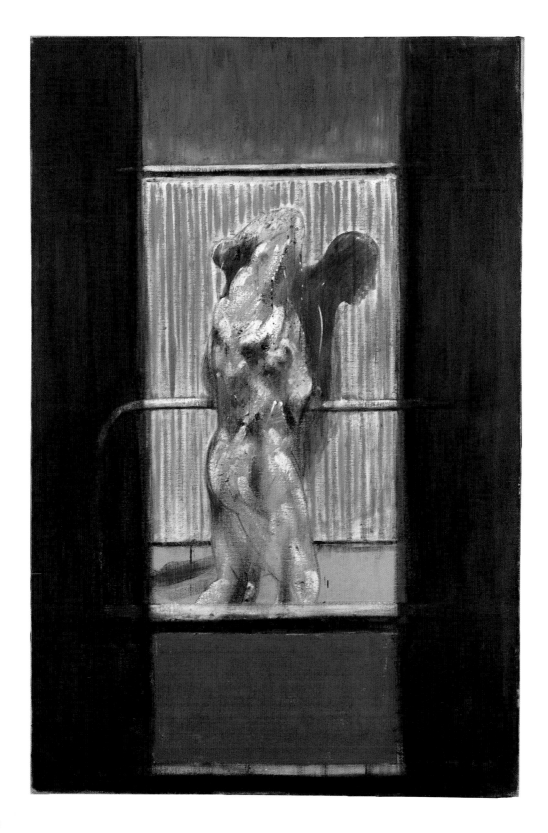

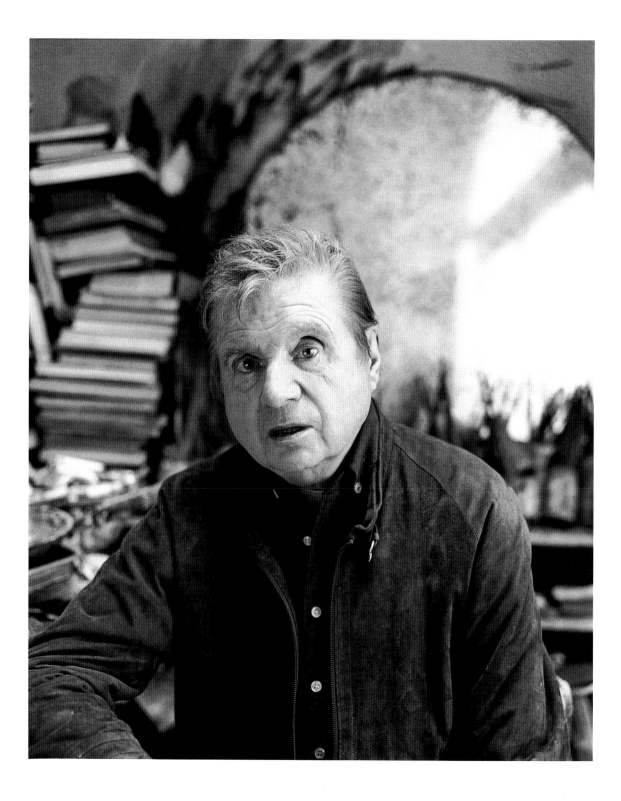

Luigi Ficacci

FRANCIS BACON

1909–1992

TASCHEN

KÖLN LONDON LOS ANGELES MADRID PARIS TOKYO

COVER:
Figure in Movement, 1976
Oil on canvas, 198 x 147.5 cm
Geneva, Private Collection

BACK COVER:
Bacon is his studio at 7 Reece Mews, London, 1977

ILLUSTRATION PAGE 1:
Triptych, 1991, right panel
Oil on canvas, triptych, each panel 198.1 x 147.3 cm
The Estate of Francis Bacon

ILLUSTRATION PAGE 2:
Bacon is his studio at 7 Reece Mews, London, 1982

© 2003 TASCHEN GmbH
Hohenzollernring 53, D–50672 Köln
www.taschen.com
© for the reproduction of the works of Francis Bacon and related material The Estate of Francis Bacon 2003
© photo/backcover: Carlos Freire/photo12.com
Project management: Petra Lamers-Schütze, Cologne
Coordination: Christine Fellhauer, Cologne
English translation: Bradley Dick, Cantalupo in Sabina
Production: Ute Wachendorf, Cologne
Layout: Catinka Keul, Cologne
Cover design: Angelika Taschen, Cologne

The author thanks Martine Orsini and Mauro Nicoletti for their kind
assistance.

Printed in Germany
ISBN 3–8228–2198–5

"My whole life goes into my work"
The Poetics of Francis Bacon

Perhaps no artist of the 20th century expressed in painting the tragedy of exist-ence more realistically than Francis Bacon. This does not mean the dramatic force of an abstract condition of human life or the representation of something that might accidentally happen in one's personal life, but the inner and unrep-resentable sense of individual and intimate existence. In Bacon, rendering the sense of existence inevitably provokes a violently tragic expression. The tragic sense of existence is not a constant theme in every civilization, but it is a specific condition of European man in the modern era. And Bacon confronts it with such a concrete, penetrating, and truthful interpretation of human nature as to trans-form that sense into an immanent and disturbing reality. On the contrary, the objective reality of life becomes an appearance for him, which only the practice of painting can transform into a current and flagrant value. It is in the reality of the work, in its eternal present that the drama of subjective existential experience projects onto the sphere of tragedy. This interpretation of the sense of human life, mixed with explosive energy and desperation to the point of hysteria, is much truer than any realistic representation. Through its complete subjectivity, it cuts to the quick of an observer's most intimate sensibilities. Behind the grow-ing awareness of the greatness of Bacon's work in the context of the 20th century is the fact that his paintings are anything but realistic, in the sense that they are not bound to any particular representation of appearances or episodes belonging to a specific, real event. Nevertheless, they are motivated exclusively by the expe-rience of real existence in its most empirical sense: the reality of a transpired fact is resolved in the reality of the artistic act – the act of execution in a form. With the force and profound resonance of expression, Bacon's paintings push the ef-fort to comprehend human nature, its concrete form and functioning, and its feelings to the extreme. The starting point for his artistic activity is his own life. In Bacon, the experience of existence is lived through all the senses and powers of the human being and not through the primacy of the eye. On the contrary, this, like the rational intellect, drowns in the ambiguity resulting from the syn-thetic simultaneity of the senses. To arrive at the image that permits him to grasp something of this ambiguity and make it become reality, assume form, Bacon strikes an extremely hypothetical, daring, and risky course. Just like a bet made at the poker table or the horse races, every work can succeed or fail the moment it is executed. His judgment of the outcome of pictorial performance is drastic

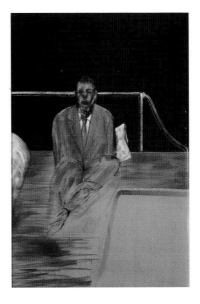

Study for Figure II, 1953 and 1955
Oil on canvas, 198 x 137 cm
Mr. and Mrs. J. Tomilson Hill

ILLUSTRATION PAGE 6:
Painting, 1950
Oil on canvas, 198.1 x 132.1 cm
Leeds, City Art Gallery

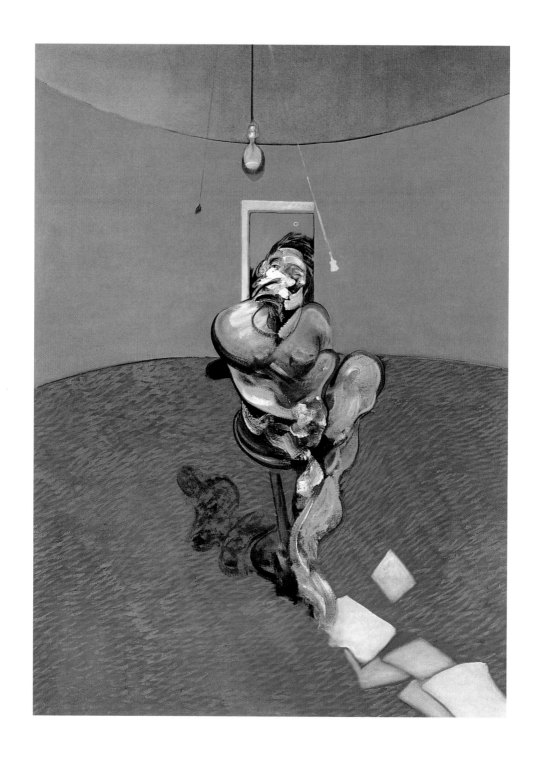

Portrait of George Dyer Talking, 1966
Oil on canvas, 198 x 147.5 cm
Private Collection

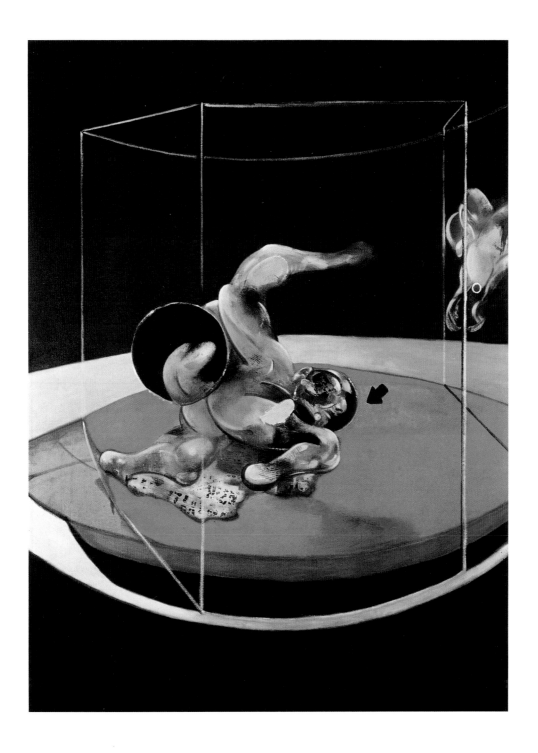

Figure in Movement, 1976
Oil on canvas, 198 x 147.5 cm
Geneva, Private Collection

Head II, 1949
Oil on canvas, 80.5 x 65 cm
Belfast, Collection Ulster Museum

and extreme, devoid of objective references other than those that belong to his own instantaneous aesthetic judgment. It is an absolute judgment that frequently led him to destroy many of his works and cast aside yet others, pitilessly selecting episodes of his penetration into the unknown of painting. Practice prevails to the point of excluding theory, and with it any sort of preconception. Theory belongs to a rational system, and Bacon knows, from the very start, that you cannot get out of this system using rational thought, but only by subverting it. Practice is the only force capable of eroding the system and embarking on an extraordinary and unknown multiplicity of directions. Bacon's thematic choices are not what make the impact of his paintings so forceful. There is no characteristic theme separable from the totality of his painting, that could autonomously exert a communicative effect. There is no element in his images that so powerfully belongs to existence that it allows you to read his paintings as the explicit illustration of something that can be communicated in a similarly incisive way, transferring it to other forms or other techniques, as would be possible if themes prevailed in his works. Instead, it is Bacon's ability to touch the deepest and darkest sensibilities of an individual that makes his paintings extraordinarily true and thus real. And since the ultimate aspiration that, beyond historical differences, renders European art of the 15th century so common with modern-day reality is the achievement of truthful expression, Bacon's work is essential to understanding the spirit of the 20th century. No one more readily than he, after the epochal trauma inflicted on humanity by the events of World War II, expressed the singular tragedy of the individual in a society that was externally victorious and marching inexorably towards progress, a progress that apparently could not lead anywhere else than to well-being and clarification of all the obscure aspects of existence. But this objective merit was not among his initial intentions. On the contrary, there was no initial intention in his paintings other than the need to paint his own life. However, his act of painting was ferocious, extreme, and desperate, and not a preconceived thematic choice. It is this fact that imposes a tragic sense on the figure, that links it with the tragedy of existence; indeed, it expresses this tragedy. Thus, Bacon the artist is essential to an awareness of modern man. Modern man is brutally vested with the means to comprehend what mix of violence, anguish, and anxiety of the sacred, desire, desperation, degradation, the search for love, and animal abjection there is in his own matter and how this necessarily constitutes the raw material of beauty.

Over the last few years, studies of Francis Bacon's work have made great progress, exploiting an extraordinary quantity of documentary materials pertaining to both his life and works. We now dispose of a vast body of detailed information about the biographical and cultural circumstances that accompanied the execution of individual works. But in order to grasp the fundamentals of his poetic, we must set aside this documentary information and limit ourselves to an interpretation of eleven masterpieces from different phases of his career. This will allow the elements of his art to emerge integrally, in the uniqueness of his works – in their exceptional formal genius.

ILLUSTRATION PAGE 11:
Blood on the Floor – Painting, 1986
Oil on canvas, 198 x 147.5 cm
Melbourne, Private Collection

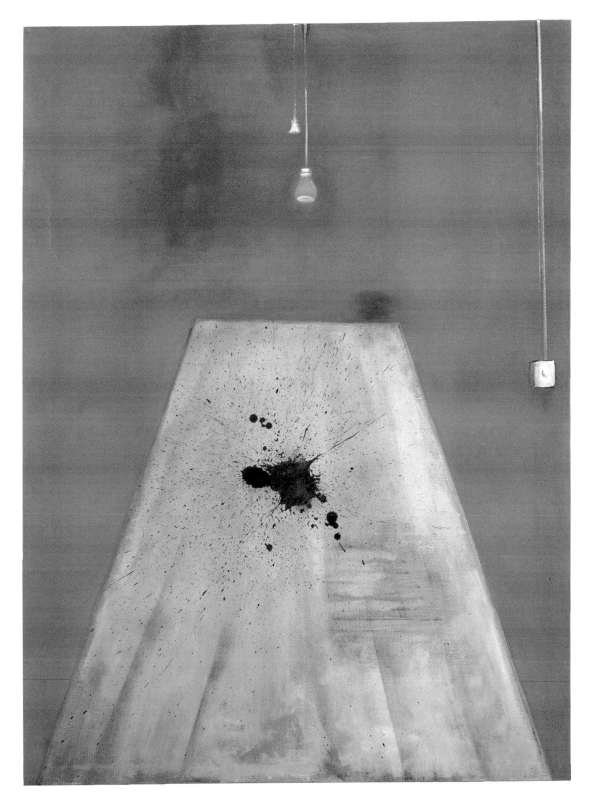

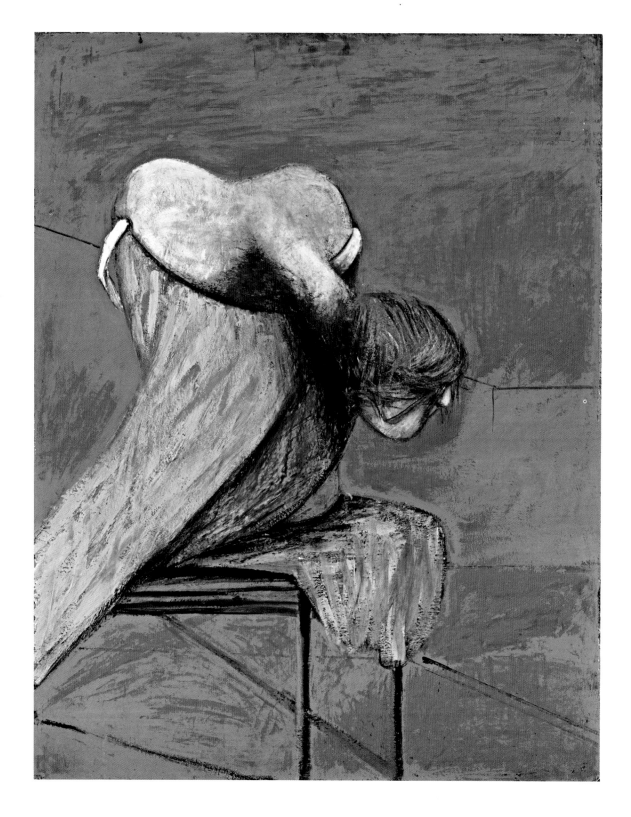

"Obsessed by life"
The Expression of Horror

Francis Bacon fixed the starting point of his artistic career on *Three Studies for Figures at the Base of a Crucifixion*, executed in 1944, although he had been painting for over a decade, had created a number of extremely interesting paintings, and had appeared in several exhibitions, sowing the first seeds of his future notoriety as an artist (ill. p. 14). *Three Studies for Figures at the Base of a Crucifixion* manifests a terrible, expressive violence. It does not represent any violent act. But some undefined and inhuman violence that occurred in an unseen space and time beyond the limits of the painting has impressed its horror on the forms and the colored area surrounding them.

The composition is separated into three distinct canvases that are coordinated so as to form a triptych. This arrangement is of such disturbing originality that Bacon afterwards used it on a frequent basis, whenever the pictorial motif seemed to require this type of treatment. The orange hue spread across the space of the three canvases so violently strikes the observer as to overwhelm all powers of perception and eliminate the possibility of reading the forms according to common conventions of rational logic. A single sentiment unifies the figures,

Three Studies for Figures at the Base of a Crucifixion, 1944
Oil and pastel on hardboard, triptych, each panel 94 x 74 cm
London, Tate Gallery

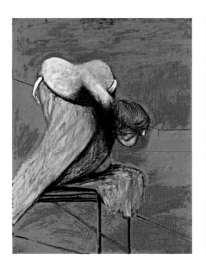 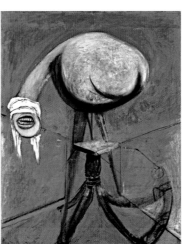 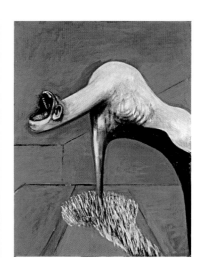

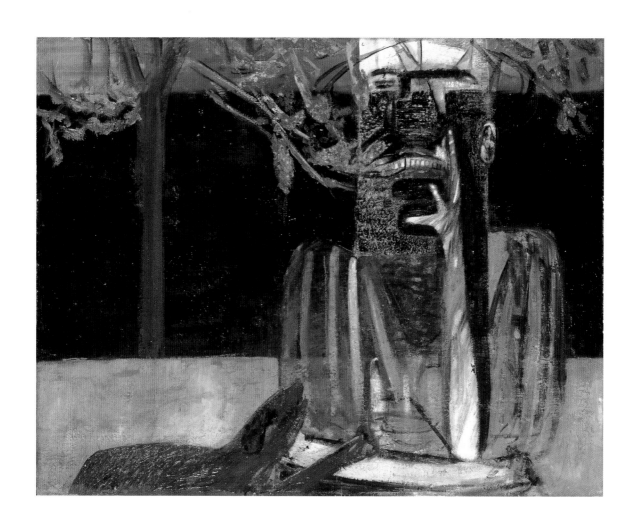

Figures in a Garden, 1936
Oil on canvas, 74 x 94 cm
Private Collection, on loan at the Tate Gallery, London

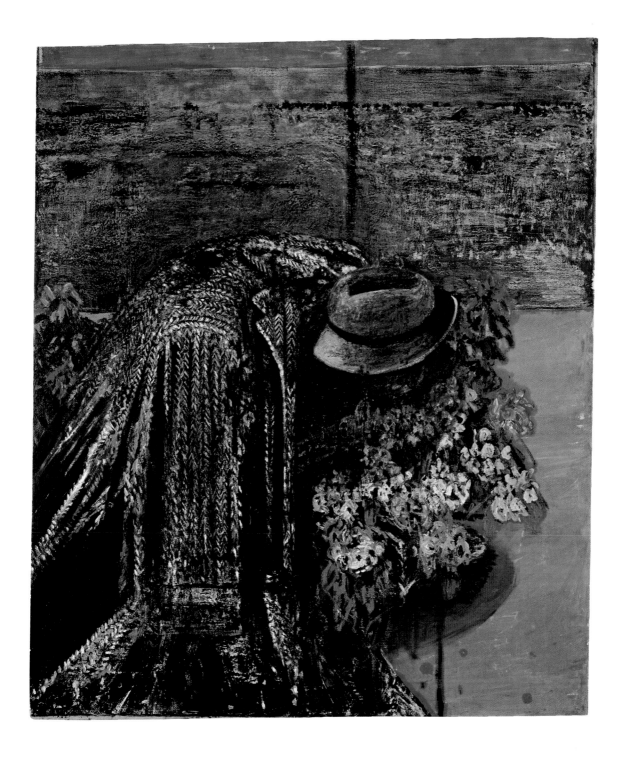

Figure Study I, 1945–1946
Oil on canvas, 123 x 105.5 cm
Edinburgh, Scottish National Gallery of Modern Art

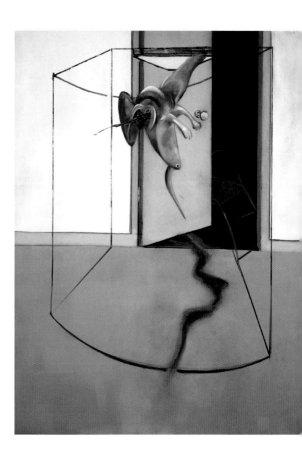

Triptych Inspired by the Oresteia of Aeschylus,
1981
Oil on canvas, triptych, each panel 198 x 148 cm
Oslo, Astrup Fearnley Collection

each of which is isolated on its own canvas: it is a furious, suffering, and horrified expression, of victims and witnesses to something whose effect is an atrocious sense of tragedy. The human and bestial elements composing the figures, all rendered ambiguous by their respective deformation, are so impenetrable and enigmatic as to thwart comprehension of any explicit meaning. Any attempt to deduce prior intention in the morphology of these bodies by means of logic will fail, collapsing in admission that this painting leads into an unknown area, at whose boundaries conventional logic must halt. In Bacon, painting is not a field for the imitation of apparent reality, but an independent and artificial act emerging from the innermost and most instinctive needs of the individual, dominated exclusively by the profound, wild force of expression. What the contradictory composition and mingling of the bodies' grey magma with other colors transmits in *Three Studies* is the lacerating expression of a cry, regardless of its nature and cause. It is a cry reduced to its wild force, beyond the normal human need to identify and resolve the causes of malaise. More animal than human, so excessive as to become unaware of its own expressive implications: it is no longer capable of communicating anything intelligible. The very obscurity of the origin of this sensation and the likely identity of the visible subject allows the image to avoid any particular illustrative significance and penetrate instead to the quicker and more intuitive level of the mind: where sensations act, such as the modes of awareness that precede logic and run deeper than it.

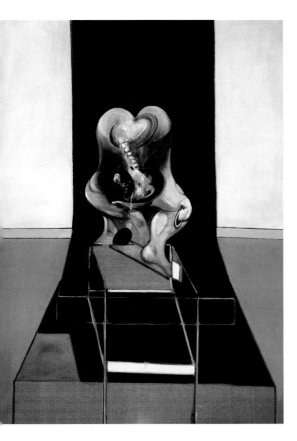

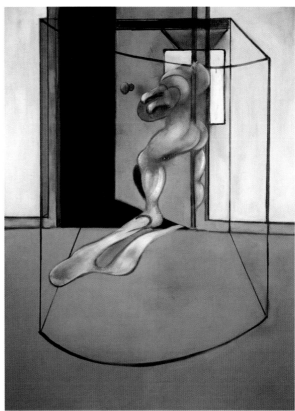

Bacon needs to renounce natural logic and upset it in the act of painting in order to reveal and transform into comprehensible terms something originating in the unconscious: the complex, multiple, and contradictory mass of emotions and the obsessive images that arouse it. This is its material, nothing other than the experience of human existence and the unconscious substrate over which it passes. Through revelation of the unconscious in painting, the insignificant existence of the individual rises to the grandness of a mythical experience: to a condition that transforms an infinitude of empirical experiences into the tragic story of mankind.

The magmatic orange surface is blinding, to the point that space is perceived more at the psychic than logical level. The struggle of pictorial composition reveals the traces of lines, partial geometrical figures interrupted during the construction of space. They are residual fragments of what painting in the past had used to delineate an organic configuration of man's architectural or natural environment around the human figure, the setting in which he was the measure and central point of reference. This representation of space dominated by man could express much of the narrative and symbolic intelligibility of the image. Of this impossible perfection, which fell to pieces in the wreckage of modern civilization, nothing survives in the chromatic magma of Bacon's work other than fragments that are perceptible with the same immediacy, plunging into the depths of the unknown abyss of the mind and the other sensations that constitute the material of the painting. They are the traces of a tragedy that is identified with

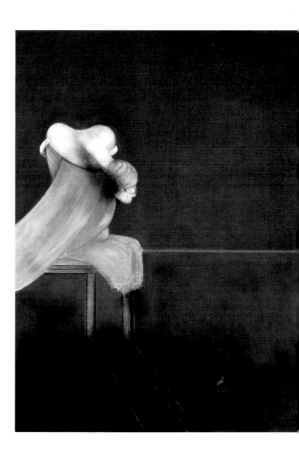

Second Version of "Triptych 1944," 1988
Oil on canvas, triptych, each panel 198 x 147.5 cm
London, Tate Gallery

the progress of history, in the innermost way, not in distinct episodes, but with the same rhythm: the terrifying and vital rhythm of the transformation of man and his culture. Biomorphic typologies burst into this work from the history of human civilization, recalling certain figures of bathers by Picasso from the 1920s, at the limits of the comical and the grotesque. They are forms that emerge from artistic culture, but with the same forcefulness of a mental obsession. The resulting figure is a traumatic expression of the horror that originates in profound feelings, revealed by artistic memory and the history of painting, felt as if it were living matter. It is as if Bacon had encountered Picasso's creations along the course of his imagination, as if it were a beaten path. He himself would define his conception of his historical sources in art as "a formal armor."

An infinity of clues in the painting, and an infinity of clues in the historical memory of the subject looking at the work show that the horror is provoked by the immanent drama of a catastrophe for which mankind is responsible (this triptych dates from 1944, a time when the conscience of Europe was upset by the horror of war). But the true object is the expression of horror in itself, superior to any specific and transitory cause. A relative cause might allow it to be overcome. But horror, as an integral force of existence, beyond all the contingent evidence that experience might have known, permits neither distractions nor progress. What Bacon does is grasp the most universal expression of horror through the force of painting: by giving form to a wail. Because the figures do not illustrate any action, the key to understanding the nature of their presence

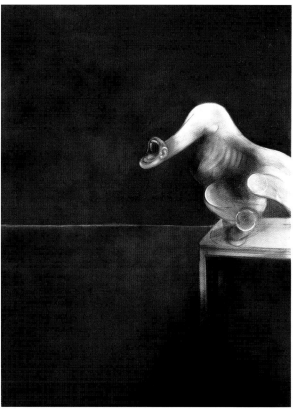

is implicit in the expression, "Studies," that enigmatically appears in their title. This expression is foreign to the representation of reality, belonging instead to the most specifically academic tradition of artistic work. Indeed, the figures are in the preparatory state of suspension in which every artist of any epoch places his model when he starts to transform it into the image of his inner world. If Bacon gives the work a title like "Studies," which refers to a neutral condition of artistic work, it is because this preparatory act of traditional painting practice becomes the very object of the image. And in imposing this limit, he manages to transform his own existential experience into sensation and to express it as a universal force. Indeed, this is one of the most radical ambitions in modern art, where the real subject of the work is art itself.

In *Figure in a Landscape* (ill. p. 20), dating from the following year, the figure is set in a natural landscape. The artist's desire to frame a foreshortened view of a natural park offered him the occasion to create one of the most extraordinary paintings to appear in those years. With the inventive freedom of his painter's genius, Bacon covered the white gesso foundation layer of the canvas with black marks laid in fast, cursory fashion like imaginary ideograms that let the underlying white show through the tempest of arabesques and black and gray streaks created by his brush, highlighted here and there by touches of ochre and red, crisscrossed by smears and reflections of the blue sky. The result is a sequence of chromatic fields that, without describing the park hedge, express a vivid, mobile,

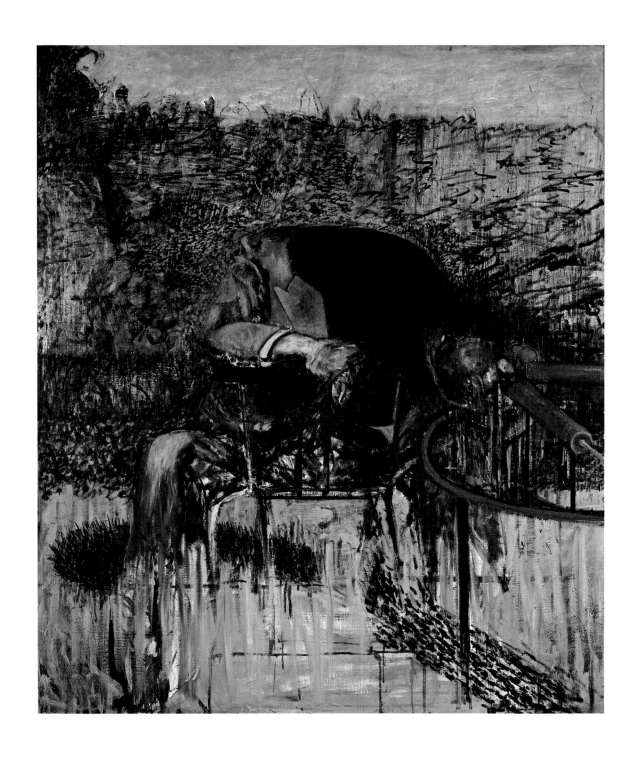

Figure in a Landscape, 1945
Oil on canvas, 145 x 128 cm
London, Tate Gallery

and invasive sensation that ultimately overflows its own explicit object of representation. The dense vegetation becomes a furious and menacing organic sensory experience. So many times, in so many paintings of the grandest tradition of the past, landscapes and the rendering of a soft, natural detail resulted in representations of such powerful autonomy and freedom of expression as to emerge as episodes vested with their own appeal, ready to transcend the particular significance of the specific case and engage the sentiments and even sensuality of the observer. Instantaneously and almost instinctively reliving this typical condition of classic painters, the effect that Bacon evokes in the pictorial battle waged on his canvas, in that solitary "hand-to-hand combat," as he himself defined the execution of this work, is the sensation of destructive fury and obscure terror that finds no logical justification in the explicit subject of the image or in the programmatic intention of the painting. On the contrary, a reassuring detail like the streak of sky that delimits the top of the hedge and should suggest a quiet setting for this scene instead foments our disquiet in the clash provoked by its own comforting glow. The effect of this blue is to provoke an unconscious digression that exasperates the sense of tragedy evoked by other, more explicit and specific signs. The fury of execution follows its own logic, the logic of the pictorial form emerging from the clash of inner and largely unconscious tensions, without foreknowledge of their conduct and outcomes. At that point, the rhythm of pictorial execution suddenly overwhelms the logic of realistic representation so that the figure's head disappears, disintegrated in two opposite areas or incoherent masses of chromatic effects, the result of erasures and scraping in sections where it is impossible to perceive any natural form. But these points of nebulous confusion are the emotional acme of a sense of horror expressed by the achievement of a formless organic material. It is as if, due to an excess of expression, the head, face, and word had incinerated the organic functioning characteristic of their natural model, leading the figure to a repellant and grotesque state of abjection. Then, the iron bench, a normal detail of park furniture, becomes an intrinsic appendage of the figure. It loses its realistic quality and passes over into the realm of absurdity occupied by the round, tubular structure supporting the microphones that appears on the right and will become a recurrent, obsessive element in Bacon's work. Their juxtaposition is absurd, just as their appearance in later works is absurd, and we have no key to their interpretation, not even in terms of a system of meanings that is alternative to that of conventional logic, as had previously been the case with Surrealist culture. Here, every detail certainly has its own source and own reason, which is more or less contracted and distinct. But the passage through the pictorial process, which in Bacon radically subverts all preordained intellectual systems, deprives it of its organic quality, so that the fragments end up as no more than obsessive auras of their origins, permitting no other interpretation than that of their form, that is, the form of a painting.

The level of expressive violence in the paintings executed immediately before and after World War II, was immediately rocked in *Painting 1946* (ill. p. 22) by an agonizing inspiration that was so extreme as to force harsh, pointed, and previously unknown characters into the picture. The most powerful of these is a ferocious sarcasm that reveals a recurrent expressive motif in Bacon's work: a violent humor that is often disproportionate, grotesque, cynical, and outrageous. The snarling mouth of the monster that is the protagonist of *Painting 1946*, produces an indefinable impression, between a sardonic smile and the asthmatic

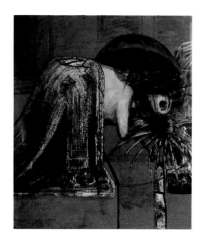

Figure Study II, 1945–1946
Oil on canvas, 145 x 128.5 cm
Huddersfield, Huddersfield Art Gallery, Kirklees
Metropolitan Council Permanent Collection

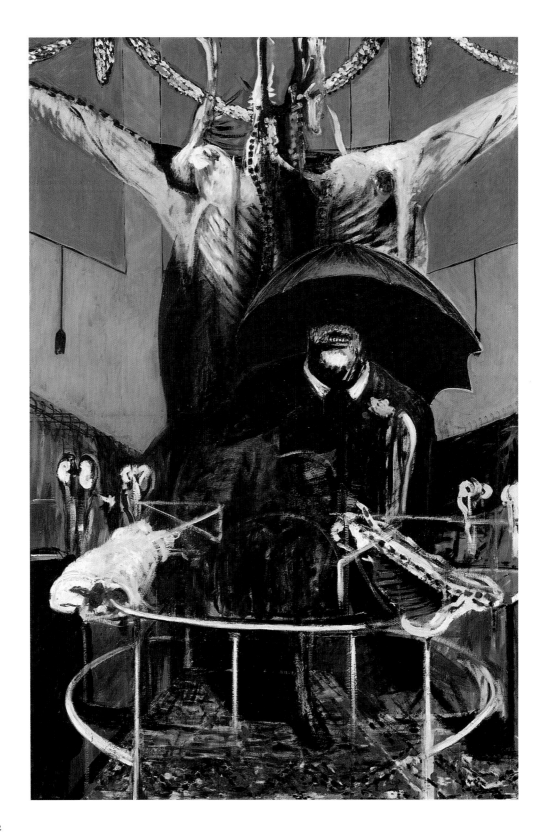

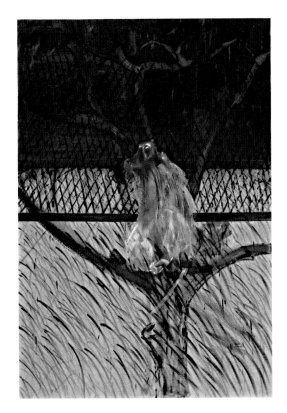

effect of an impostor emerging from plethoric, dark oppression. Within the overall sense of macabre repulsion and horror for the perverse, blind violence inherent in the figure, here again no explicit content and no literal significance can be deciphered in the painting. Through its monumental display of incongruous juxtapositions, *Painting 1946* imposes the condition of absurdity as a coherent expressive reality. This approach, which appears here in all its obscene and horrifying plainness, will endure as one of the fundamental elements of Bacon's poetic. Different elements arouse the observer's sense of indecency, but the determining factors depend more on the structural components of the work than on explicit figurative details. The composition of this painting testifies to a mysterious adventure of modifications during its realization: Bacon started with the intention of depicting a landscape. As he proceeded, he inserted the motif of a chimpanzee in a field of grass that almost overwhelms it. This then evolved into a bird of prey, but the changes continued until everything was jumbled up in the final image, where the field has disappeared and only traces remain of the chimpanzee and the bird, even if they have been incorporated in other ideas or indistinguishable impressions. The outcome results from a learning process that is infinitely vaster and deeper than the logical-rational approach. The profound, pre-rational faculty that emerges when a nearly superhuman force subverts the conventional order of knowledge is called sensation. And it is this that Bacon arouses and elaborates in the act of painting: it is a blind condition, because neither its nature, orientation, nor outcome are defined. It is a condition that transcends the normal state of the human condition, driving existence into a

ILLUSTRATION LEFT:
Study of a Baboon, 1953
Oil on canvas, 198 x 137 cm
New York, The Museum of Modern Art

ILLUSTRATION RIGHT:
Untitled (Landscape after van Gogh), 1957
Oil on canvas, 127 x 101.6 cm
The Estate of Francis Bacon

ILLUSTRATION PAGE 22:
Painting 1946, 1946
Oil and pastel on linen, 197.8 x 132.1 cm
New York, The Museum of Modern Art

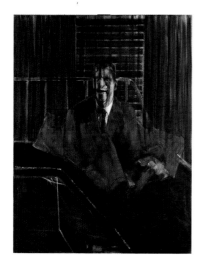

Study for a Portrait, 1953
Oil on canvas, 152.5 x 118 cm
Hamburg, Hamburger Kunsthalle

state of hypersensitivity, where it too is unaware of the outcome. Of all possible tools, what painting represents for Bacon is that which allows him to grasp elements of absolute reality in the journey through this dark entity: the interior absoluteness of having stopped and possessed a fragment of the hostile objective flow in an authentically subjective, and thus true, vision, where it is illusory precisely on account of its objectivity. Substituting the expression of subjective reality for the illusion of an objective reality also represents the fundamental process of art in the modern era. Bacon renews it by fully immersing his painting in the sensations of existence.

Like all his works, *Painting 1946* preserves traces, residues, and fragmentary signs of the original motive, of a thousand sensations derived from experience. But these traces cannot be recomposed according to the logical system that they themselves broke in the moment when they crossed over from the realm of existence to that of art, and take form. For the painting to render residues of real experience stripped of their realistic sense, the bold comicality that derives from a substantial mystery impresses logical sense on their absence. Comicality and mystery are common conditions of the malaise of existence.

Painting 1946 is based on inseparable complexes of sensations, exasperated by the certainty that what the observer now sees in this painting is that the figure itself emanates horror, that it is its cause and maker.

The figure's centrality, frontality, and isolation reinforce the evidence of this presence, magnified by the embracing background, by the macabre triumph of the carcass behind it, by the balustrade separating it from the outer world, from all the grotesque and terrible clues that, by confusing its identity, atrociously affirm the sensation of its baleful, malevolent, and despotic authority. The image's space is articulated in an altered convergence of perspective, as if it were thrown off balance by the exaggerated intensity of the color and its application in a pictorial gesture that shapes the magma and organizes a tendentially circular conclusion around the figure. The figure swells to monstrous proportions, magnified by this exasperated spatial convergence and the looming presence of the quartered ox, which hurls the colors back towards the outside and engages them in intense contrasts with the chromatic composition of the butchered meat, with the blood-red pastes and whitish, yellowish, and bluish materials that project reflections and contrasts on the swollen area. It is this milieu, so active in a rhythmic sequence of absorption and contrasts, that magnifies the figure and simultaneously isolates it from the external reality of the painting. However, it is clear that it is essentially a rhythm of forms and relationships of colors that act to express the horror and, at the same time, blinding beauty. It is the beauty of pictorial composition, something that is totally pertinent to the transformation of sensation into expression. Bacon affirms it with dizzying lucidity, when he speaks about the process through which this image was formed: "Suddenly the lines that I'd drawn suggested something totally different, and out of this suggestion arose this picture." Thus, the subject of the painting is a problem of lines: an autonomous formal issue. As a thematic identifier, this title imposes a neutral entity with respect to a representation, on the contrary, an academic entity, insofar as it refers to the sphere of making art: "painting." It demonstrates the primacy of reality in the act of painting. It is a clue that what the observer sees before his eyes is not an illusion but a painting, and likewise the year of its execution, neither more nor less – the absolute nature and time of the work. For this reason, Bacon's entire output bears titles that are totally abstract with respect to illustration of an act; instead, they are empirically exact with respect to what the observ-

ILLUSTRATION PAGE 25:
Jet of Water, 1979
Oil on canvas, 198 x 147.5 cm
The Estate of Francis Bacon

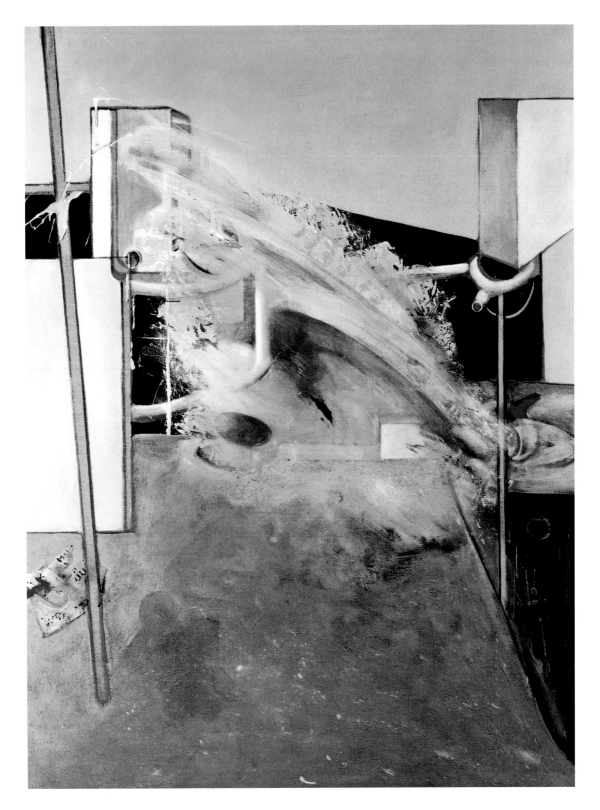

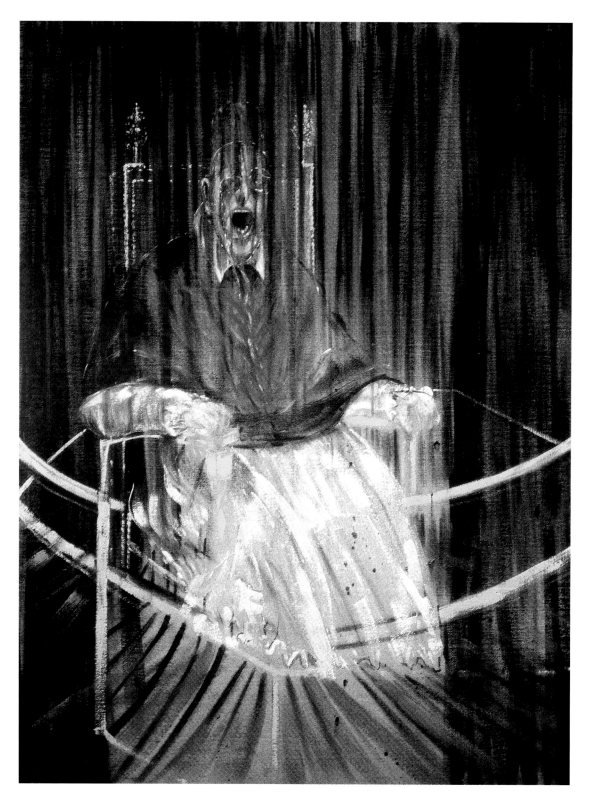

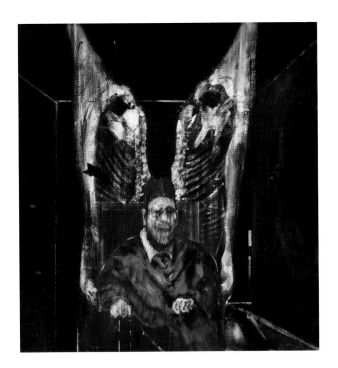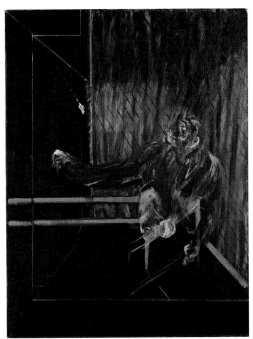

er concretely has in front of him – the outcome of an artificial practice. At this point, the painting represents an unequivocal fact, the only one capable of revealing the relativity and transforming the foreignness of reality, in which mankind is confused and conditioned by a preordained mental system that prevents him from acquiring authentic, original knowledge of things. But since the image has a composite nature, reflecting the process of the artist's immersion in the painting with all the fullness of his existence, both material and spiritual, intuitive and reflective, Bacon wants to distinguish it radically from contingent reality. Emerging from the chaos of its creation, the image is irremediably scarred by its own fragility, drama, and desperate beauty, in short by its being a precious indication of truth at this point. To forestall the misunderstanding of interpreting the painted image as an imitation of reality, as ancient aesthetics dictated, Bacon insisted on highlighting the artificial nature of the illustration or narration of something connected with empirical reality. To emphasize and defend this diversity that gives rise to a difficult and, once again, desperate alternative reality, he banishes the forms of reality from the painting. Afterwards, he tries to distance the entire object, the painted picture, from mingling or being confused with reality. He prefers placing his paintings in heavy frames that distinguish them from the context, even going to the extent of protecting the painted surface with glass that, while protecting the natural form, impede our visual contact with it by adding a further element of interference, the reflection of light. At this point, from an accidental nuisance, the reflection becomes a rhetorical tool: the real spectator sees himself and his real outline reflected in a painting that is intermittently perceptible and thus becomes impenetrable, distant, and mysterious itself. It is a mental disposition not dissimilar to what often led Bacon – an exceptional interpreter of past masterpieces of art (over the course of time, he would take up works by Picasso, Degas, Velázquez, and Michelangelo); indeed,

ILLUSTRATION LEFT:
Figure with Meat, 1954
Oil on canvas, 129.9 x 121.9 cm
Chicago, The Art Institute of Chicago

ILLUSTRATION RIGHT:
Chimpanzee, 1955
Oil on canvas, 152.5 x 117 cm
Stuttgart, Staatsgalerie Stuttgart

ILLUSTRATION PAGE 26:
Study after Velázquez's Portrait of Pope Innocent X, 1953
Oil on canvas, 153 x 118.1 cm
Des Moines, Nathan Emory Coffin Collection of the Des Moines Art Center

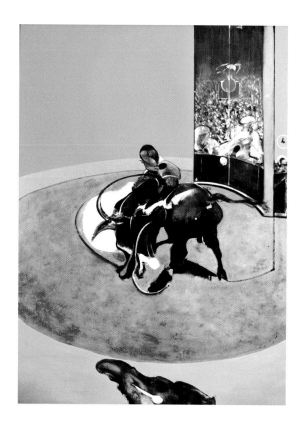

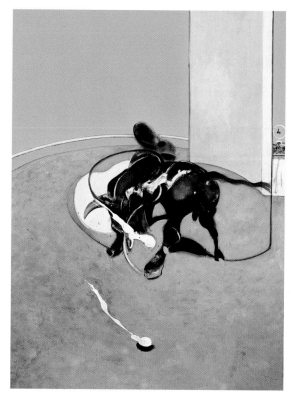

he was such an attentive and original observer as to conceive of some paintings by the great masters as sources of penetrating inspiration to the point of obsession – to avoid looking at the original copies of the masterpieces from which he derived his own developments, preferring to use the intermediate form of reproductions. There are numerous, complex justifications for this phenomenon, and not least of these is a feeling of fear of recognition of the unique sacredness of the idol in the work. An idol of a superior idea of human superiority: art.

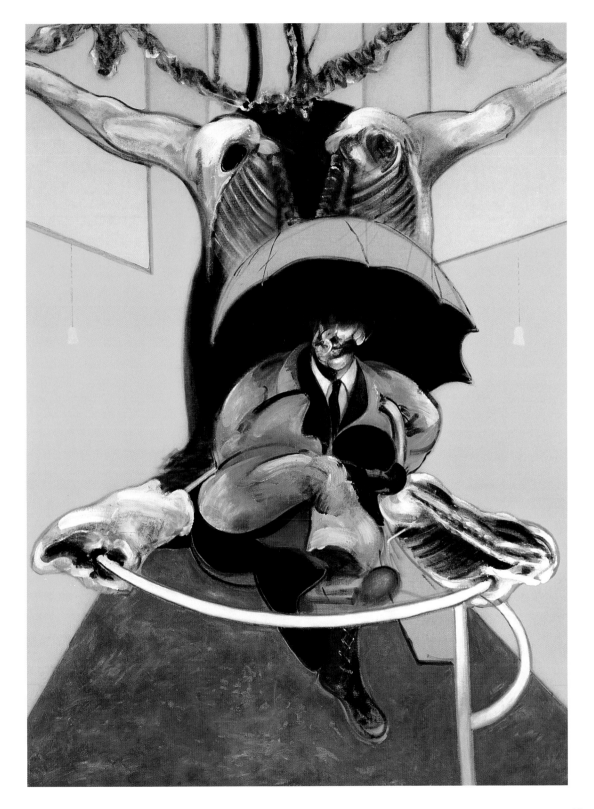

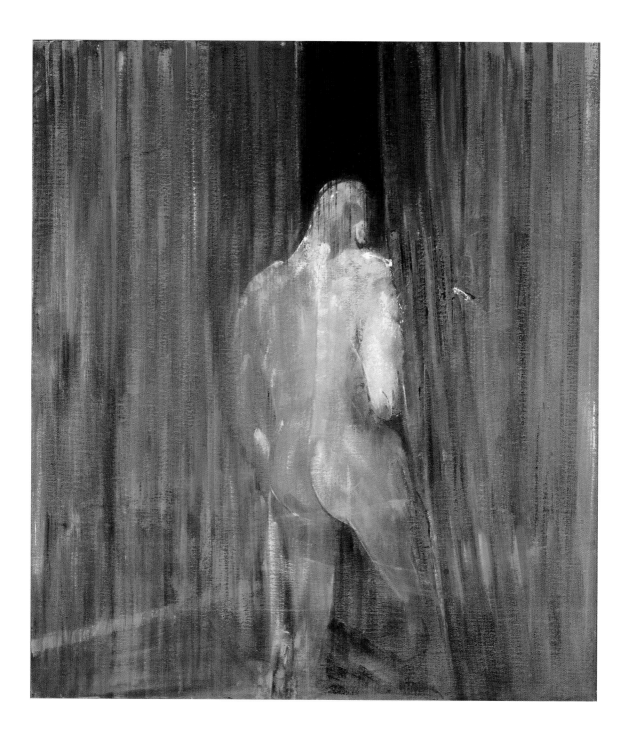

"The sensation without the boredom of its conveyance"
The Human Body

Study from the Human Body is a gorgeous painting from 1949, recognized only recently as one of Francis Bacon's masterpieces.

The origin of the work lies in Bacon's desire to confront the possibility of a modern representation of man in his figurative integrity. This was his initial critical concept. But, inseparably from the aesthetic problem, the world of the nude's sensory implications comes into play. Bacon goes to the heart of the matter. He dispenses with all tentative restraint and directly confronts the statue, the most formidable genre ever invented in the history of culture, from ancient to modern times, to render the effect of humanity's illusionary realism, striving to remake it. This is the genre in which Western civilization most openly places the artist in competition with the divine.

In *Study from the Human Body*, the human body is a whitish chromatic mass formed on the ochre background of the canvas. The latter is the active part of the tinted compound that surrounds the figure, together with the black gap towards which it is moving, and the shower of vertical streaks, from pearl to lead gray, of the curtain that it is passing through, moving out of sight.

The man is composed of an accumulation of paint applied with the palette knife, like a clay mock-up preparatory to execution of a sculpture. But the sense of anthropomorphic physicality that 20th century sculpture achieved in the statue, restraining any possibility of fluidity or mobility, bears down on the figure like an expression.

And yet the volumetric structure is caught at the point where the analogy with statuary starts to crumble. Consequently, at the climax of the poetic experience of the figure's departure from the scene, it disappears into the darkness behind the opaque curtain.

The power of the palette knife, impressed upon the figure by the painful force of the painting process, is the outcome of a superhuman effort, the agonizing reaction of the painted subject to a state of prostration and impotence. It is like the condition of a hero fallen from dominion over the world, from familiarity with himself and things, from the divine property of being at the center of a perspective and harmonious reality. Painted subject and real subject identify with each other in abstract synthesis, in colossal confrontation with the loss of the ability to attribute reality to the thing, the lost recollection of this almost divine faculty.

Untitled (Figure), 1950–1951
Oil on canvas, 198 x 137.2 cm
The Estate of Francis Bacon

ILLUSTRATION PAGE 30:
Study from the Human Body, 1949
Oil on canvas, 147 x 134.2 cm
Melbourne, National Gallery of Victoria

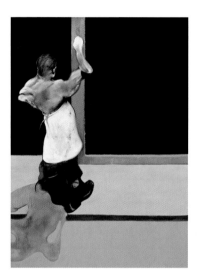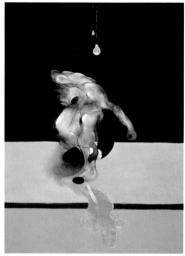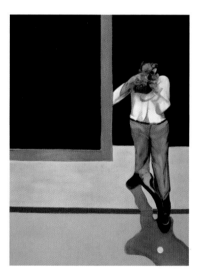

Triptych March 1974, 1974
Oil on canvas, triptych, each panel 198 x 147.5 cm
Madrid, Private Collection

ILLUSTRATION PAGE 33:
Figure in Movement, 1978
Oil and pastel on canvas, 198 x 147.5 cm
Private Collection

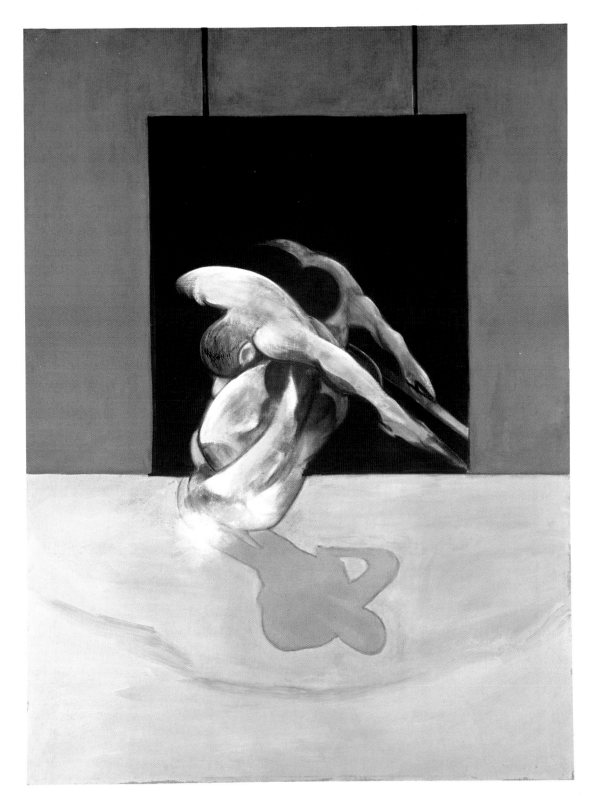

33

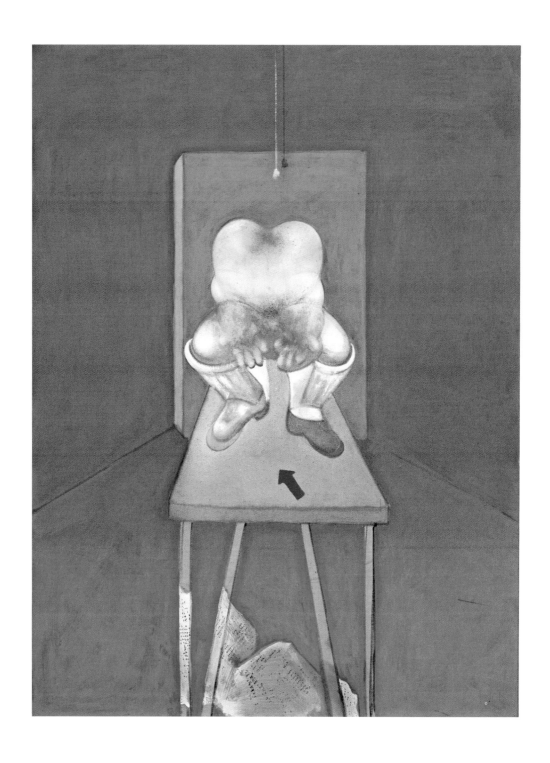

Diptych, 1982–1984: ***Study of the Human Body***, 1982–1984; ***Study of the Human Body – from a Drawing by Ingres***, 1982
Oil and transfer type on linen, 198.5 x 148 cm and 195.5 x 147.6 cm
Washington DC, Hirshhorn Museum and Sculpture Garden, Smithsonian Institution

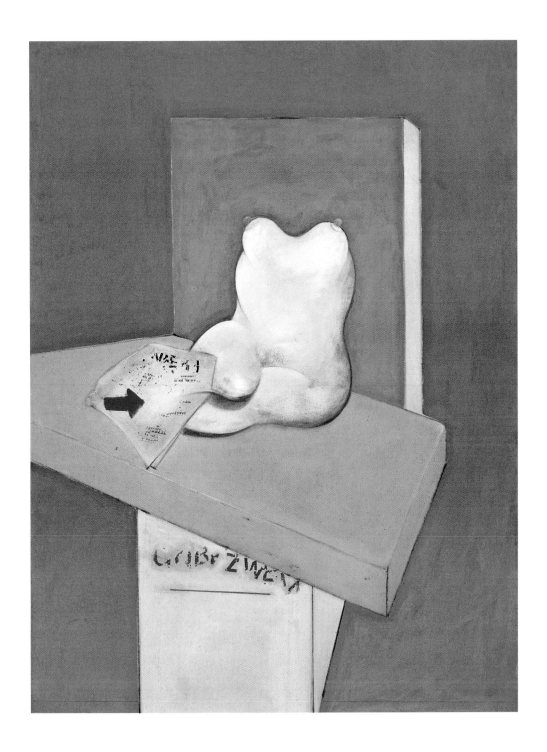

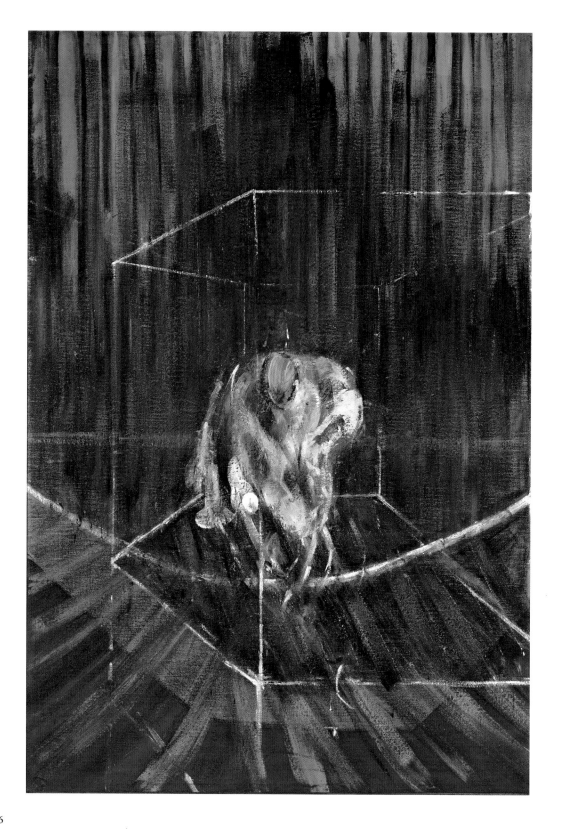

The figure is full of sensuality. Its cadence emanates a powerfully corporeal sensation, at the limits of the bestial. It expresses an intermediate condition between the unconscious and absurdly erotic aspect of the animal and the insolent animality of the human figure. It also expresses the persistence of a component of force that is simultaneously vanquished by the vulnerability of its own unconsciousness, like a body moved by instinctive forces. The figure's movement is the outcome of a strangely contained and compressed energy, like a determining force that, when it becomes true, provokes a conflict of opposing forces. The power of the human figure is inseparable from an unconscious vulnerability like that which the animal, even the most powerful or ferocious animal, can involuntarily reveal to the hunter who is observing it. Just like a hunter or primitive predator, the painter attacks the figure both to defend and nourish himself, having observed it from the most original and unusual points of view, to exploit its weak point and slay it. All of this takes place in the color and behind the monochromatic tonality, in an extraordinary complex of low-toned chords.

In a work like *Untitled (Crouching Nude)* it is clear that painting is everything for Bacon, and its elements are entirely resolved in chromatic expression. It is not possible to distinguish between line, color, and planes of space. Painting is now an instantaneous action in which he uses all the tools that the inventive process requires, without distinction or hierarchies amongst them. In *Crouching Nude,* as in the other paintings dating from this phase, the pictorial act is manifested in a context of low tints. The overall effect is monochromatic, so that any moderate differentiation of color is exalted with respect to the constant darkness of the gray, dark blue, and black that absorb the hue. The act of painting is a battle that reveals its traces like scars, which are ultimately engulfed in the image.

The effort of volumetric compactness in *Study from the Human Body* (ill. p. 30), the juxtaposition of chromatic planes in *Figure in a Landscape* (ill. p. 20) and *Painting 1946* (ill. p. 22), and thus the stylistic characteristics Bacon had realized in his work up to that time are now entirely dissolved. Elements used in previous works appear again in *Crouching Nude.* The screen of vertical, pearly gray brushstrokes recurs, which was originally distinguishable as a curtain; the linear definition of geometric space recurs. An element that can be referred to that mysterious curvilinear structure recurs, similar to metal tubing, originating in some fathomless sensation that has to recover ideas connected with the furniture designed between 1929 and 1930 (ill. p. 88). The summary treatment of the surface, especially the human body, under the palette knife and paint brush also recurs. But their use, both in *Crouching Nude* and in works that are similar or from the same period, is so fast and free as to transform those motifs into something totally different from what they had meant up to then in Bacon's paintings. Extrapolated from all discursive links and loaded with their own dense expressive content, they almost assume the identity of a figure. They are no longer accessories to the anthropomorphic figure. Their autonomous force as figures acting on a different level clashes violently with the principal and the protagonist. The strokes of the curtain whose identity had become complicated in the course of evolution, to the point of becoming mere gestures announcing new types of form, are now entirely liberated from their objective origin. Here they appear as a sort of chromatic shower that cloaks and leaches the body's features, marking it in such a way as to seem a scar inflicted by existence and the tragic journey that transformed the vestiges of existence into an image. At the height of maximum transfiguration, this chromatic shower re-

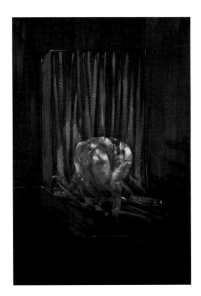

Study for Nude, 1951
Oil on canvas, 198 x 137 cm
Private Collection

ILLUSTRATION PAGE 36:
Untitled (Crouching Nude), 1950–1951
Oil on canvas, 196.2 x 135.2 cm
The Estate of Francis Bacon

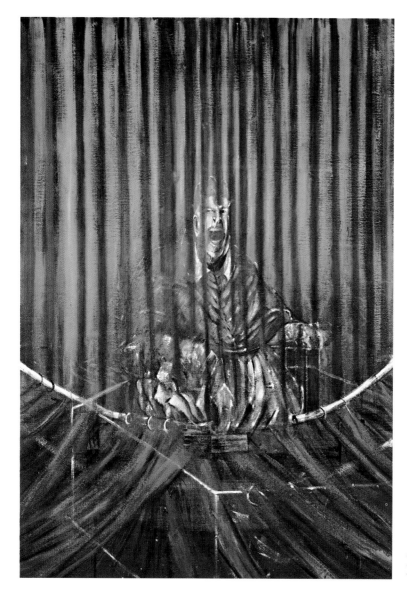

Study after Velázquez, 1950
Oil on canvas, 198 x 137.2 cm
The Estate of Francis Bacon

stores with traumatic profundity the sense of a diaphanous curtain, of lumi-nescent crossroads, that rendered the first appearances of the curtain, for example in *Study from the Human Body* (ill. p. 30), something more than an object. Instead, it is the expression of an indefinite state of consciousness, a chrysalis capable of spreading uncertainty and doubt over any visible appear-ance of the painting. It is a sort of psychic emanation that materialized in an object through a sensory and obsessive process.

The image of space underwent a similar evolution. The geometric lines of the paintings from around 1944 had changed in Bacon's work to assume the semblance of an isolated volume closed around the figure. Now, in *Crouching Nude*, the geometry of whitish lines on the black and red of the background

colors lends this scheme the appearance of a transparent change and an effect of extremely intense frequency, as if it were composed of crystal walls. In reality, this structure does not delineate any object of constraint, even if the constraint exists at the level of sensory effects. It is like a perspective box that has lost its centrality, a complex, unitary system deprived of its absoluteness and framed by a point of view that, according to the rule, would not be admissible. Now, instead, with a dizzying sense of the unknown, this decentralized vision reveals an exceptional form. It is a relative blood clot, a residue of perspective predicated on the man being at its center, lost in the middle of such an extended vastness as to make him appear as a detail, a fragile figure bound by something that seems to be his desperate attribute, drowned in the midst of prevailing forces. It is the mixture of clashing forces that produces the pictorial performance, living and ungovernable in any preordained system, at the very moment when Bacon tears down the unified spatial system, constructed according to the central idea of man, leaving a partial outline set off center from its original and all-embracing condition of dominion. The perspective box, which is distorted and incongruent, now contains only the empty volume surrounding the nude, with the absurd and paradoxical persistence of a formal rule. This residue is necessary to guarantee the manifestation of the figure, thereby resisting against the forces that would provoke its dissolution. It is like the vestige of a professional convention, obstinately observed even in the uncontrolled context of the catastrophe. This convention contains something crucial, the synthesis of an entire civilization: it is the image of its perspective system. For Bacon, it is the way to recover the figure

ILLUSTRATION LEFT:
Man Kneeling in Grass, 1952
Oil on canvas, 198 x 137 cm
Milan, Private Collection

ILLUSTRATION RIGHT:
Figures in a Landscape, 1956–1957
Oil on canvas, 152.5 x 118 cm
Birmingham, Birmingham Museums and Art Gallery

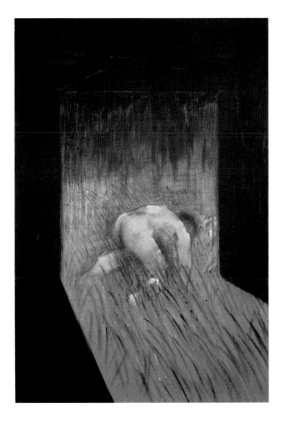

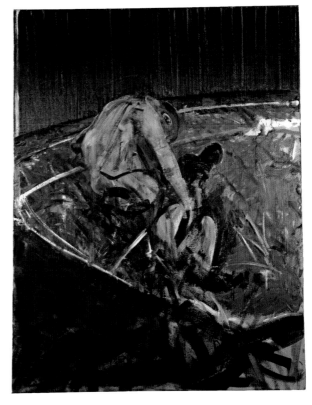

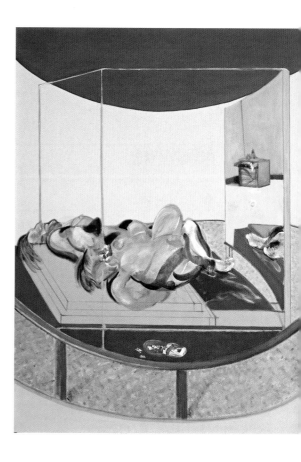

*Triptych Inspired by T. S. Eliot's Poem
"Sweeney Agonistes,"* 1967
Oil on canvas, triptych, each panel 198 x 147.5 cm
Washington DC, Hirshhorn Museum and
Sculpture Garden, Smithsonian Institution

from dissolution; a crucial step in the relationship between figure and surroundings seen in his previous painting. With the most enlightening precision and in order to dispel any assumptions as to his particular subject matter or symbolic intentions, Bacon himself justifies the recurrence of this sort of transparent cage in certain paintings from 1949 on: "I use that frame to see the image – for no other reason." He wants to clarify that the reason is exclusively for the purpose of composition, as necessary to form a specific image, and thus it is neither a metaphorical nor literary solution. He uses the spatial framework to center the figure better during the creative cataclysm represented by his painting process, to separate it from the indistinct and undefined area of the canvas, from the continuity of the real world and, finally, to prevent the image from retaining the atmosphere of the external world and instead make it become a tale about the world, its imaginary semblance. Now, in the squared off volume suspended in space, the development of Bacon's spatial exploration has achieved the most radical realization of an off-center and oblique point of observation, an idea that had already appeared in subtle form, but never with this formal fullness. This decentralization now assumes the irremediable fall of the subject from its own centrality. The pictorial exaltation of this condition of decadence imposes such a capacity of visual purification on the scheme as to vest it with a power and density of expression analogous to what is intrinsic in the figure.

In accordance with the absolute coherence that only aesthetic reasoning can know, every creation ("image," in Bacon's terminology) requires its own treat-

 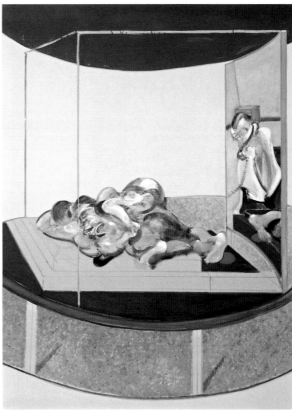

ment and, within, its own eventual manner of spatial framing. In other cases, instead of a similar framework in pseudo-perspective, this same function can be performed by a structure derived from a painted form that originally had the function of an object and, finally, the realism of an identity rendered unambiguous by its transfiguration, to the point of appearing as a pure field of abstract color. Or, finally, it might have become something almost inseparable from the figure, like the intermittent entity between the appendage and the pedestal, as had already appeared in the figures of *Studies for Figures at the Base of a Crucifixion* (ills. pp. 12/13). The triptych scheme that, after its first appearance in 1944, will predominate in Bacon's paintings from the 1960s on, extends the motif of spatial definition to the entire image, to the point of coinciding with the medium and dividing it into three physical fields in space. It could be said that the determining cause of this type is in the abstract reasons of the image: "Just to see it better," as Bacon said about the spatial frames he drew on his canvasses.

Like other paintings from the same period, *Untitled (Crouching Nude on Rail,* ill. p. 43) takes a Michelangelesque male nude as its subject, even if it contradicts its possible source of inspiration by crouching in spasmodic poses or losing the ideal compactness of corporeal volumes, dissolved under brushstrokes of pale hues. In this group of paintings (ills. pp. 30, 36, 37, 43, 47), the incarnate figure appears at fitful intervals, with its plasticity partially blurred by washed out areas or overwhelmed by suddenly violent strokes whose gestural quality gains the

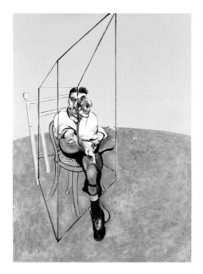 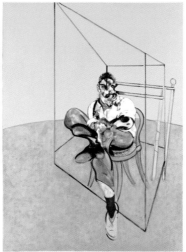 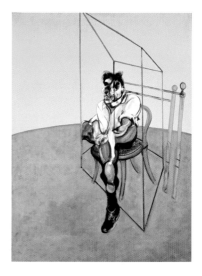

Three Studies of Lucian Freud, 1969
Oil on canvas, triptych, each panel 198 x 147.5 cm
Private Collection

upper hand over conventional, classic equilibrium. But within the dark, nearly monochromatic tones that characterize this phase, *Crouching Nude on Rail* introduces an eruption of blue that completely upsets the tonal atmosphere at the time. The curtain motif wholly absorbs this blue tone. Thus, a curtain of brilliant streaks invades two thirds of the painting, crossing over the upper portion that the black, linear geometry could have depicted as the sky. Reflecting off and mixing with the hue of the background or the figure or structures defining its space, these dense lines define the atmosphere like fine chromatic dust, varying from azure to sky blue. As in Cézanne's paintings, or Degas' pastels, this chromatic mark passes through the corporeal forms with its perceptible matter, just like the informal areas of the painting. This matter is an abstract quality that does not belong to any of the represented objects, but instead constitutes the painting's atmosphere, the projection onto the concrete material of the pictorial form of that deep and synthetic howl welling up from inside the most original and poetic unconsciousness of the subject, and materializes the point of contact and conflict, which are otherwise elusive, in the truest intimacy of the individual and objective exterior. But Bacon, who has a command of historical suggestions to the point of wholly absorbing them in his own language, pursues directions of development that make him entirely forget Degas or Cézanne and hinder immediate identification of their inspiration. At a certain point in the struggle to execute the painting, the blue area can assume divergent and disjointed rhythms with respect to the relative equilibrium that it started to affirm in its parallel and vertical treatment. The pictorial gesture suddenly curves in brutally uncoordinated trajectories. It is as if the impetus of execution guided the painter's hand in a state of blindness so that it would express the most concrete consequence of creative obsession, without mediation by his acquired aesthetic parameters. Nevertheless, the divergent blue areas at the bottom of the painting impose a sort of dynamic and non-descriptive spatiality that instead provokes a psychic impression.

This effect, which violently impacts the observer's immediate psychic perceptions, sweeps away all conditioning by the naturalistic origin of that form. It is something that expresses the corporeal deflagration of virile anatomy at the

ILLUSTRATION PAGE 43:
Untitled (Crouching Nude on Rail), 1952
Oil on canvas, 193 x 137 cm
Private Collection

42

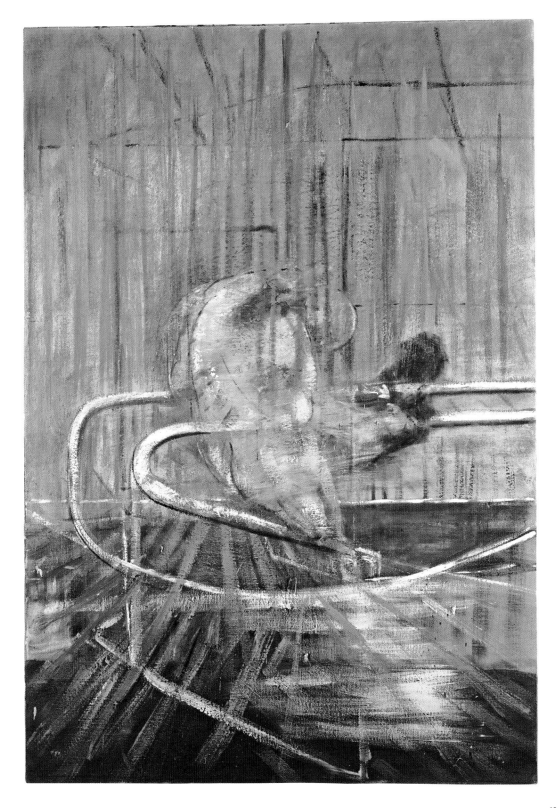

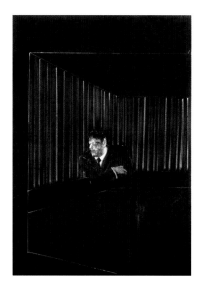

Man in Blue I, 1954
Oil on canvas, 197 x 135 cm
Rotterdam, Museum Boijmans van Beuningen

ILLUSTRATION PAGE 45:
Reclining Woman, 1961
Oil and collage on canvas, 198.8 x 141.6 cm
London, Tate Gallery

height of its power, whether it involves an athlete engaged in physical activity, such as a swimmer or diver competing in the heat of competition, or some other suggestion. Perhaps an icon to launch the imagination could illustrate something pertaining to subjects of this type, almost unconsciously recorded in he vague visual experience of the artist. But once a realistic image appears almost by chance, as if captured by an involuntary reflex of the artist's omnivorous appetite (for Muybridge's photographs or the infinite output of periodicals and daily newspapers), it is immediately upset by the congeries of extraneous sensations originating in an indistinct magma of the unconscious and experience that fill it like an empty form, inverting its functionality and appearance. And if at this point the original image develops iconic characters that can further dazzle the observer's psychological and perceptive system, it is due to its own impact on the world of sensations, which are for the most part not consequential and even unknown and unknowable. Emerging from the deep, they ultimately express themselves only through effects, semblances of meanings, and allusions to representations, figurative elements derived, through distortion or otherwise, from what was the initial realistic image, which was then radically upset by the conflict with artistic elaboration. In *Crouching Nude on Rail*, the body is captured in an attitude of maximum anatomical tension, which already contains its own deflagration and stripping of flesh. The tubular metal structures, which isolate the figure in a confined area, like the delimited field of its manifestation, are a recurrent and inseparable spatial parameter. Beyond the illusory imitation of natural reality, the figure articulates itself and acts in consequence of a clash of forces. Dynamic contrast is the condition for its artificial movement; it is caught at the height of the clash, which is so intense as to generate stasis, stiffening its fragmentary and residual parts, the consequences of this clash, just like the violently gestural marks made during the painting process.

But the blue chromatic marks glowing irregularly around the figure are the principal agents of this sense of dispersion of energy. The black marks that appear in the sections subject to the greatest bleaching and obliteration of the body express the most macabre and, at the same time, sensual effect of the figure's dissolution, the cruel dissection of its physical mechanism. Concealment of the lower part transforms the heroic anatomy of the nude into the semblance of one of Goya's monsters, spasmodically inhibited by amputation of its original power. Like a negative, hyperbolic excrescence, the figure projects its own shadow in front of itself, in the ambiguous doubling of a turbid corporeal sensuality and also exaggeration of a violent contradiction with it. In its undefined prehensile state, the shade, rendered concrete by the reality of its pictorial expression, lends itself to constituting the objective, negative, and intangible form of a general motif of the subject's doubling or deprivation of power. It is like the hyperbole of a sensory entity of the figure and at the same time the dense, transfigured projection of desire, at such an imprecise and traumatic level as to appear exceptionally relevant to the unexhausted need for sensory knowledge that agitates modern man.

The expression in *Two Figures* (ill. p. 47), dating from 1953, is largely determined by the power of the subject: the emotional impact of the image of erotic, homosexual coupling determines the extraordinary quality of the work. In practical reality, erotic desire is nourished by imagery and demands that it be formed, particularly for the experience of sexual pleasure, which is one of the most in-

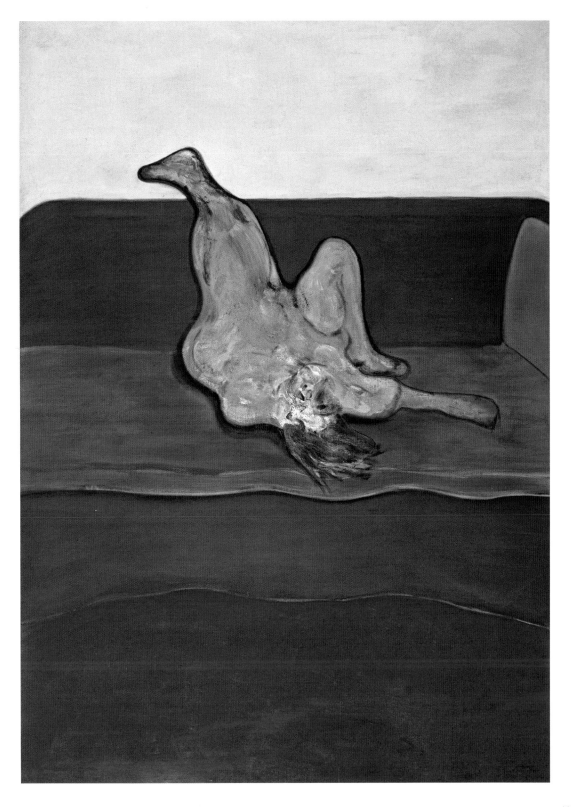

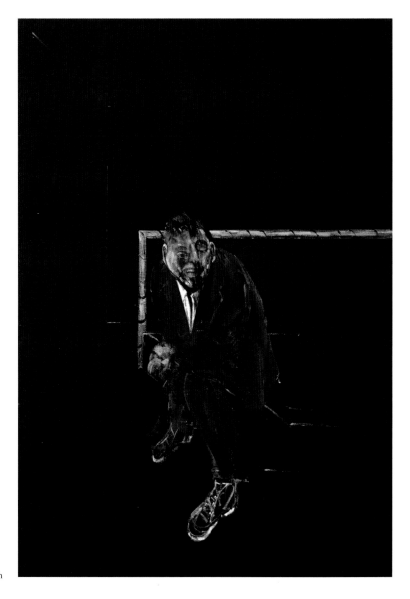

tense and ephemeral of sensations. But it is the very dynamic of the erotic grip that limits the arbitrary nature of the image in the process of transfiguration and deformation. The image that is about to emerge from the pictorial process cannot fully depart from a rendering of the original, real event, or at least evocation of something that recalls it, if it does not want to risk losing connection with the flagrancy of the existential fact.

Extrapolation of the image from its natural appearance does not permit its transformation into an abstract entity. In the case of erotic inspiration, or an episode of desire, the flagrancy of the act is an absolutely decisive psychological motive. The imaginative process must necessarily exalt the erotic obsession at its origin, even if this is in the most autonomous and condensed iconic synthesis. On the other hand, it is clear that, precisely when the senses are most excited, as

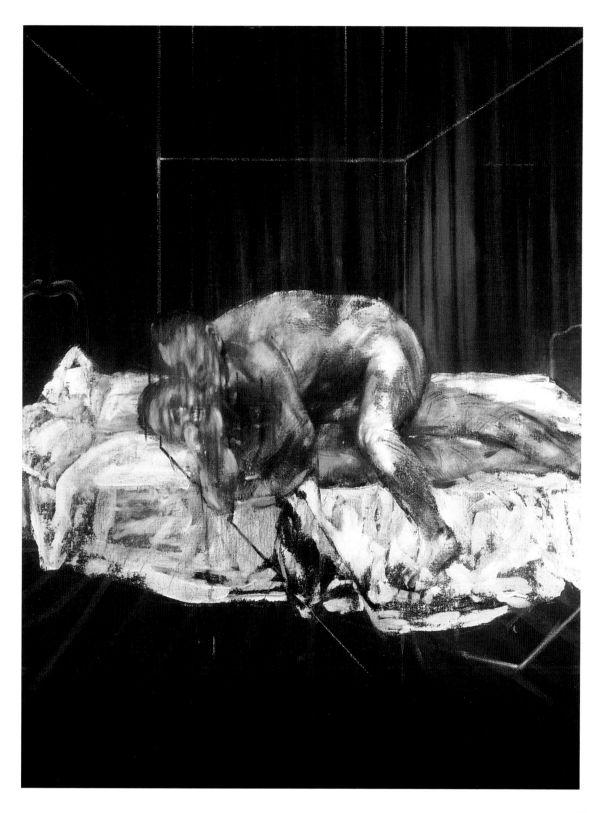

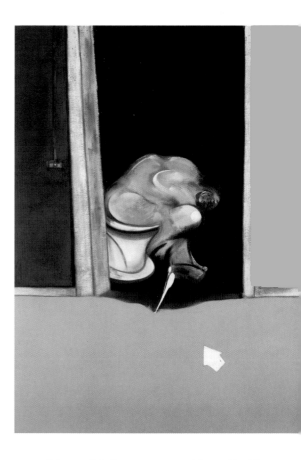

Triptych May–June 1973, 1973
Oil on canvas, triptych, each panel 198 x 147.5 cm
Switzerland, Private Collection

in the case of sex, the response of the empirical appearance would reveal its false-hood and incapacity to satisfy the desire to see. This entails a few artifices that would make it possible to grasp an intangible entity – sensation – as if it were a truly material fragment. Having to render the sensation of life, the form cannot limit itself to a vain imitation of what is merely apparent, but in Bacon, it must derive from the profound reaction of individual sensitivity to the impact be-tween existential experience and the unconscious. With this orientation, the work leads the observer to a different field, unknown to the conventional logical system of common, practical reality.

Two Figures: if the painting bears the title of a figure study, it means that the sublimity and abomination of carnal desire are projected in the formal work in order to be recognized and recreated by the subject that has suffered this desire in the condition of existential blindness. For the most intimate existential sen-sitivity of Francis Bacon, love is a struggle, sexual coupling is a struggle, and in its formal expression, the figure is a struggle between opposing elements.

There is no prior intention in this work, if not to grasp and express sensa-tions. His idea to apply them to the image of two men coupling and bind them to two precise figures, which are recognizable as his own lover and *himself,* is none other than an initial condition, not unlike others, such as a chromatic and spatial predisposition.

In fact, the determining event of the work is strictly artificial, executed and rigorously circumscribed within the values of the pictorial form: there is a basic

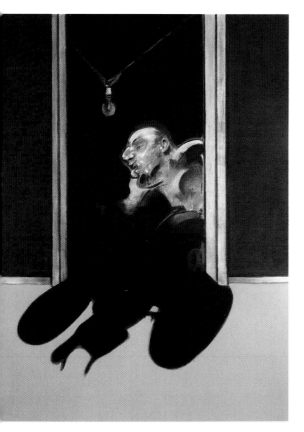

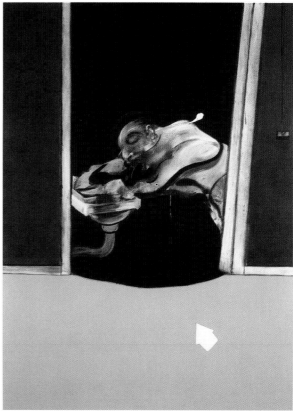

condition, where color – synonymous with a flat surface, a field – is identified with the entire work – that is, with its support – in a formal dialectic with the signs of linear geometry, which are in turn synonymous with the articulation of space. This is how the act of painting is carried out, in consequence of the original impulse received from an indistinct complex of vital sensations. It is not sex between two men, which is an antecedent fact, obsessively present in the existential state of mind, pressing and craving to leave a trace of its own allure on the imagination. In the inversion of impulses of reality that takes place upon execution of the work, all sensations act and are exalted in the wonder of a colored invention. It is wholly transformed in the whiteness of the sheet, the anthracite black of the background, the blending of whites, grays, and bluish tints on the lovers' bodies. Thus, the subject, the sensuality of the coupling, and the exasperated desire of the amorous act are rendered by the bluish gray magma of the bodies, the blurred anatomical parts, and the faces crushed by a fleeting sensation, fixed in tragic expression, trapped in the tangle of vitality and death. Almost inevitably, they become masks of horror and dissolution, victims of painful ecstasy and, like a watermark, show the opposite of their cause, the collapse of the climax of carnal excitement into the material inertia of death. The spasmodic expression of pleasure transforms into the skull's involuntary expression of horror, in its sardonic mirth. Once again, the shower of vertical marks rains down on everything, suddenly stirring in its rendition, which is reduced and lighter this time, like a particularly condensed and syncopated accentuation

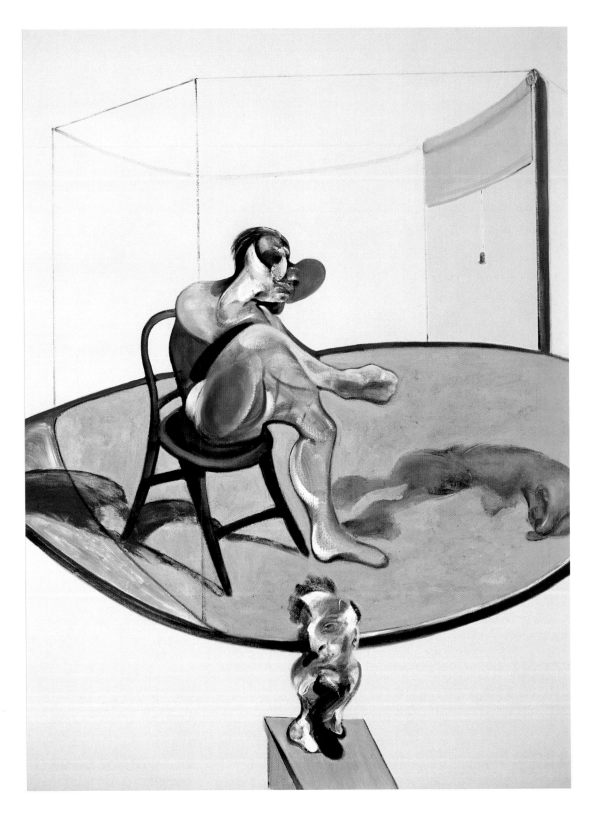

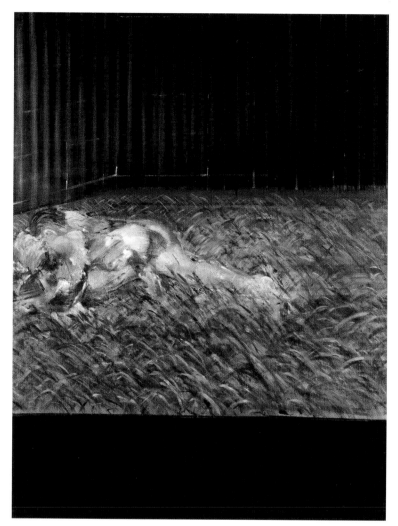

Two Figures in the Grass, 1954
Oil on canvas, 152 x 117 cm
Private Collection

with respect to the denser curtain found in other paintings. Whatever references there might be to exact circumstances in the life of Francis Bacon, at this point the interest is overwhelmed by the preeminence of the results of the artistic creative process. For Bacon, painting is the way to attempt rediscovery of the more precise flagrancy of the existential fact, and thus recreation of its reality. Bacon's painting is the superimposition and blending of a subjective mix, composed of complete bodily assimilation of existence and its objectification through formal transfiguration.

ILLUSTRATION PAGE 50:
Two Studies of George Dyer with Dog, 1968
Oil on canvas, 198 x 147.5 cm
Rome, Private Collection

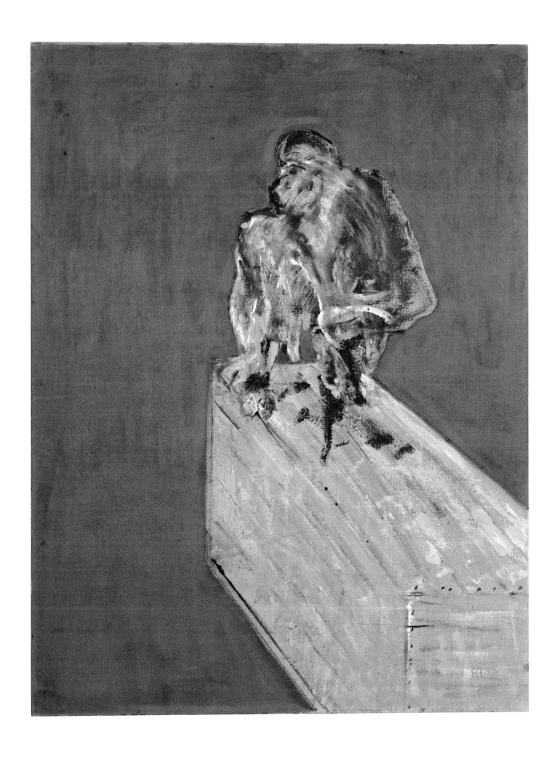

Study of a Chimpanzee, 1957
Oil on canvas, 152.5 x 118 cm
Venice, Peggy Guggenheim Collection

ILLUSTRATION PAGE 53:
Landscape near Malabata, Tangier, 1963
Oil on canvas, 198 x 145 cm
London, Ivor Braka Ltd.

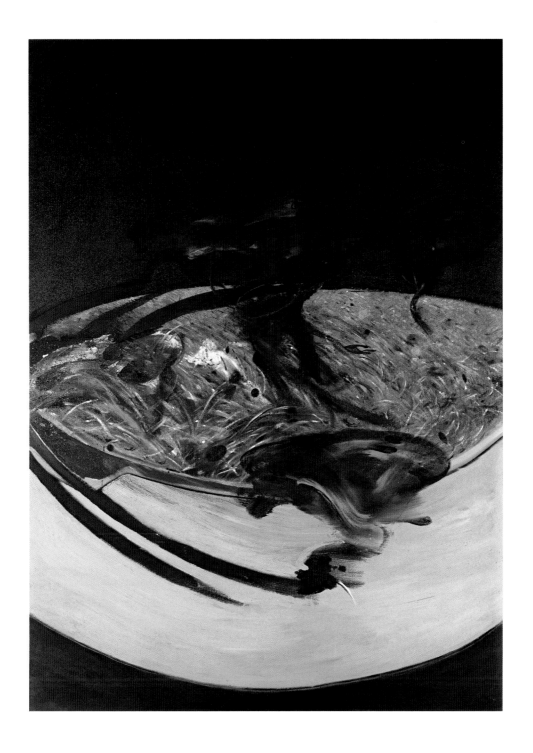

ILLUSTRATION PAGE 54:
Lying Figure, 1969
Oil on canvas, 198 x 147.5 cm
Riehen/Basel, Fondation Beyeler

ILLUSTRATION PAGE 55:
Study of a Nude with Figure in a Mirror, 1969
Oil on canvas, 198 x 147.5 cm
London, Ivor Braka Ltd.

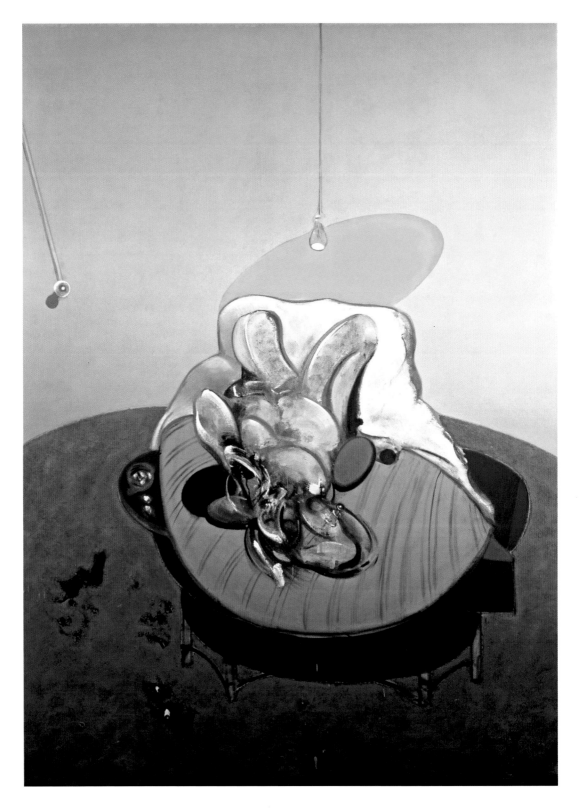

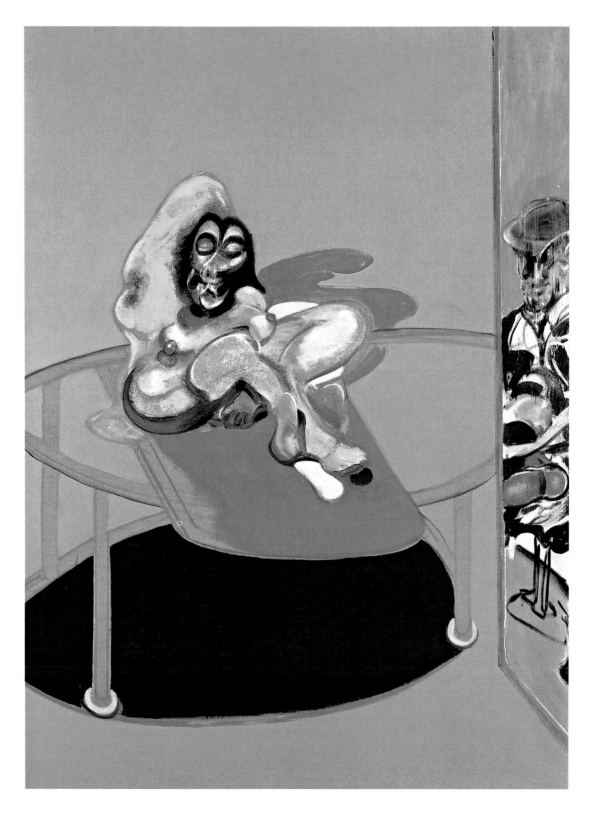

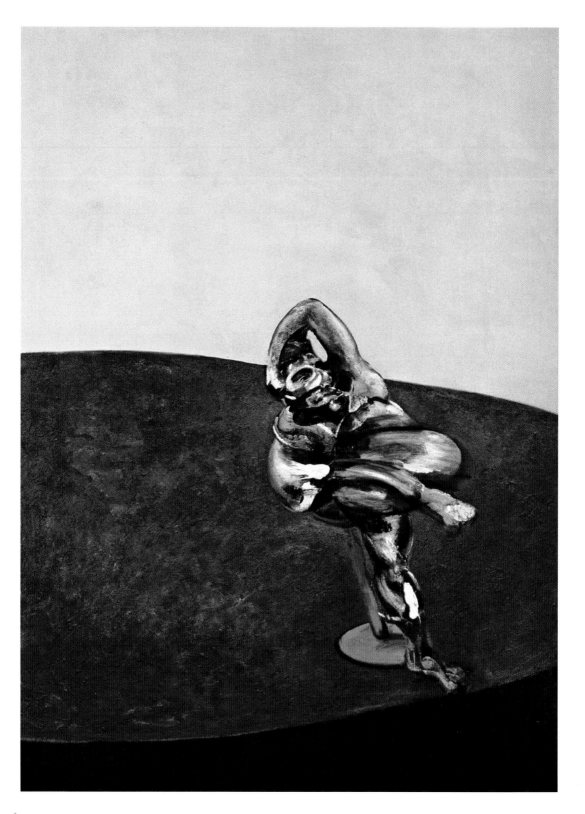

"Painting is the most artificial of the arts"
The Scene of the Tragedy

With *Three Figures in a Room*, Bacon returns to the triptych, the format used twenty years earlier in *Three Studies for Figures at the Base of a Crucifixion* (ills. pp. 12/13) and reused just once since then, in *Three Studies of the Human Head* (ills. p. 72), from 1953. When he started using it again, he carried out some major structural changes that show he had reflected on the type of medium and that this had evolved together with his other poetic motifs. These motifs included his desire to express the human body with a greater focus on the flesh, traumatized and blood-soaked, or his quest to capture the figure in everyday circumstances. He infused these motifs with a tragic dimension as if they were the representation of an arcane myth that was now profoundly connected with their new, tripartite medium. Unlike his previous triptychs, the new canvases are realized on a monumental scale and function analogously to the most grandiose multi-panel altarpieces of historical religious painting by generating an all-embracing iconic universe. By reprising this traditional technique in the large triptychs executed from 1964 on, Bacon manages to absorb the entire visible space in painting. This

Three Figures in a Room, 1964
Oil on canvas, triptych, each panel
198 x 147.5 cm
Paris, Centre Georges Pompidou

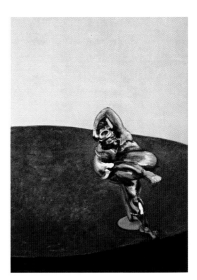

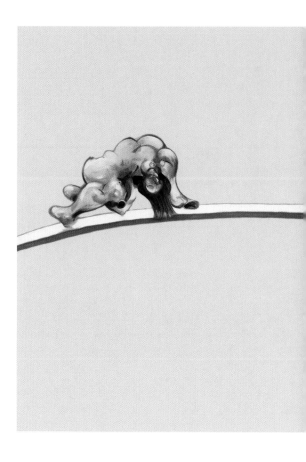

Triptych – Studies of the Human Body, 1970
Oil on canvas, triptych, each panel 198 x 147.5 cm
Pivate Collection

new conception of the triptych is an intrinsic element of the form and thus interrelates with all other components of the work, such as the relationships between space, time, figures, and colors. Thus, it marks a radical innovation in Francis Bacon's poetic.

Never before had his paintings transformed existential experience into their own essential material. The painted image now interacts with everything that is realistic or conventional and extraneous to artistic transformation, with an almost sacred distancing effect. The compelling relationship between figure and observer that had been predominant in Bacon's previous work in the single canvas format now dissolves in the triptych, extending across the unknown expanse of the field of painting. In his previous paintings, the figure was shaped according to the external subject, on the assumption that it was present, binding it to the extreme limits of his own concentration. The triptych format is now the new vehicle for achieving a vision that is not conditioned by the system of conventional intelligence. In its complexity, in its intervals of distance, the triptych plays a substantial role for the image itself. It generates an arrangement and action that are inextricable, even at the intellectual level, from the irrational logic of pictorial execution and the space in which it is realized. The observer no longer has the privilege of a central point of view, instead being excluded or functioning as a mere bystander. He is extraneous and almost unseen, although present in the form of a phantasm. His situation is somehow comparable to that of certain painted characters who, in various other triptychs, interfere with the enigmatic

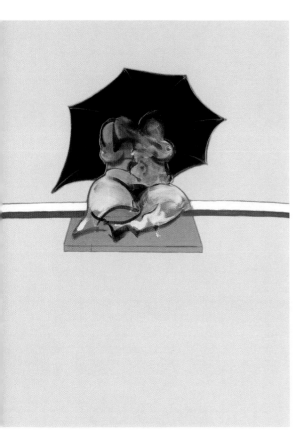

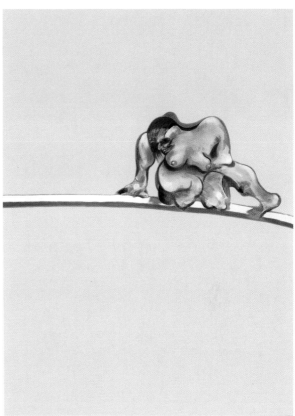

figure, intensifying his disquiet. From being the exclusive point of reference of the scene, the observer is now like a silent chorus, a passive witness to the rite of a tragic drama.

Now that the artist has dissolved the theme as an external and objective intellectual entity, he now focuses his ferocity on the most intimate manifestation of existence, where man is most vulnerable. The extreme motives that subsume any fact of life when it enters the realm of art represent the atrocious, endless path meandering between the sense of love and death, yearning towards one and slipping into the other. In *Three Figures in a Room*, the figure is molded by sudden interruptions in the vital flow, contractions, spasms that block the continuity of what is realistic in disturbed images that cannot be explained by conventional logic. The facts that assume form in the psychic reality of existence like a chaotic flow of visual stimuli now acquire an absurd fluidity in painting, which assumes an almost natural agility. The form imposes a naturalness on compositions of figures that are as artificial and profoundly forced and painful as can appear in an image. This is the unpredictable and uncontrollable final outcome of this work of passion for the human, which is what painting represents for Bacon, so upsetting and powerful as to lay the basis for its own absurdity as an alternative logic, without being related to what conventions commonly define as logical, realistic, and natural. Plodding through unknown territory is a common condition in the fallen domain of conventional logic. Every prop for perspective, narrative, and illustration that had previously appeared in his earlier works to facilitate the

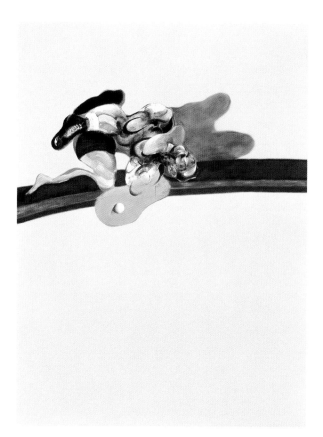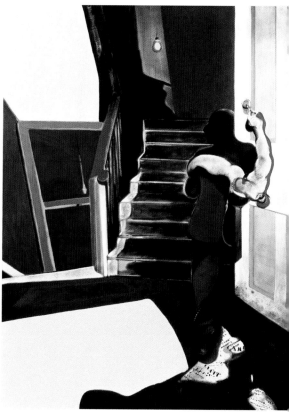

transformation of the figure into dialectal terms with an independent construction in space, no matter how abstract, traumatic, and ambiguous it might have been, is now cancelled out in the absolute fullness of the form's manifestation. The sense of menace that recurred in Bacon's previous painted works like a representative theme, residing in the sardonic passivity of the monster in *Painting 1946* (ill. p. 22) or in the uncontrollably violent and hysterical discharge of the figure represented in *Three Studies of the Human Head* (ills. p. 72) from 1953, is now expressed in its truest essence. The sense of menace then seems to shift to everything lying outside the space and time of art and its works, and returns to the real world of existential experience. It is the uncontrolled flow of chaotic forces that does not deny equilibrium and constantly seeks to shatter the clarity and need for art that is Bacon's sole condition for expressing true images – to contemplate in aesthetic form everything that externally provokes terror in the individual.

From the beginning of the 1960s, Bacon's art can establish order in the blindness of nature and existence, the only possible order that is not an illusion or an impostor and that does not belie the chaos and fortuitousness that constitute human life. Art has always exercised this process in history, at least in the West, and at least since the Renaissance: its subject matter is elaboration of the misery of the human condition, avoiding the obfuscation generated by a system of prejudices and leading man back to the expression of what is vital and true. In this process, the definition is so concrete as to substitute all other possibilities as illu-

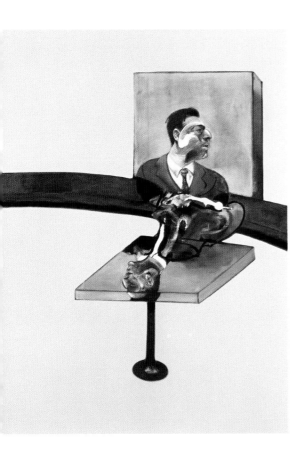

In Memory of George Dyer, 1971
Oil on canvas, triptych, each panel 198 x 147.5 cm
Riehen/Basel, Fondation Beyeler

sory. It is only in this way that man can express, withhold, and make his own
such elusive and determining sensations of life as desire, compassion, despera-
tion, and terror.

This quality of art manifests itself in an exasperated drama in *Three Figures in
a Room*, because it has become identified as never before with the elusive reality
of the experience of life. This work touches on something terribly intimate and
fleeting, because the individual and his material are acted on by a chaotic exter-
nalism that deprives them of authority and by incongruous forces that they do
not dominate. The only possibility for balance can be realized in the arbitrariness
and superhuman force of artifice: painting. It is an equilibrium without preset
rules, hypothetical and fragile, but also heroic. Upset by the onslaught of sensa-
tions that are normally repressed and hidden by the appearance of things and
the control of consciousness, the figure takes form in the hodge-podge of sensu-
ality and destruction, wounded by an agonizing violence. Its manifestation is ac-
companied by a sentiment of pity that bears the mark of an unbearable emotion-
al force, laden with the individual motives and projections of life left impressed
on the figure. Now freed from every logical context, the form does not need any
episodic clarification of the innumerable traces that reveal the overwhelming
flow of life at its origin. These traces are disquieting enigmas that do not need
clarification. The key to interpretation of the work is not found there. Recon-
structing the biography of Bacon and tracking down the constellation of
episodes at the origin of the experiences and obsessions that provoke the forma-

tion of his images is tantamount to identifying his sources. They allow us to document a network of prior relationships that aid us in discovering the motives and modes of forming the painting, the material, and the technique of the imagination, but they do not explain the autonomous quality of the expression. This is a form of thought intrinsic in pictorial practice, original and generally not rational. When it is realized, it absorbs and transfigures all motives. The reality of the execution at the physical and material level and the manual treatment of the tools constitute the expression. It is an outcome simultaneous with the gestural violence of the struggle to execute the work of art.

No other limits can be achieved than agitation in the continuous tug-of-war between opposing forces, between the pleasure of love and the progress of death, between the rise of desire and its disintegration. Nor can any other object of expression be discerned than impression, the sensation of substance that combines these two elements in an indistinguishable blend of alternating dominance and mutual obliteration. The order that, in the habits of social man and the history of culture, seems to indicate their causes and destinies has proved to be false, a system to conceal reality and deceive the individual. This protective system is an irremediable part of the past. The present does not allow us to grasp any rule or reason. But the history of mankind's continuous effort to dominate reason looms over the background of the miniscule drama of individual existence. The spasmodic and degraded contortions of the bodies recalls, the cosmic conversion of Michelangelesque titans on themselves. They were capable of symbolizing the supreme categories of the universe, time and space, the values of ideas, and human faculties, while simultaneously expressing the drama of the individual. But this is specifically part of the autonomous field of art, where through the artist's invention the past can become the material of the most crucial relevance. It is a field of irrational thought that, while stripping vital experience of its contingencies and liberating man from conventions, allows him to express sentiments and ideas that reason, neither innocent nor pure, stained by the shadow of falsehood and hypocrisy, irremediably ruins, rendering them insignificant.

The origin of every artistic motif in individual existential experience in its most profound and intimate aspects fully engages the observer's attention, with a

Triptych August 1972, 1972
Oil on canvas, triptych, each panel
198 x 147.5 cm
London, Tate Gallery

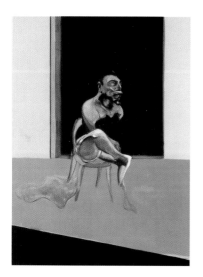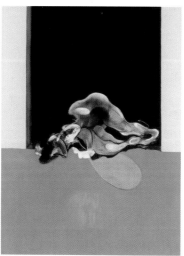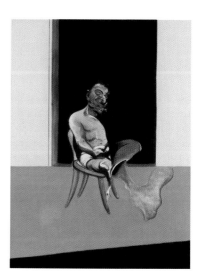

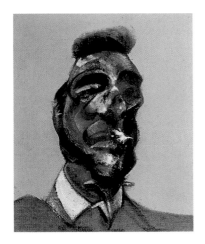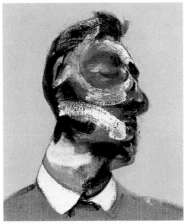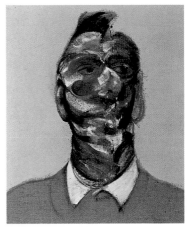

tragic lineage that even transcends the outrage of ferocious comicality present in paintings up to that time. It is now transformed into savage, tormenting sarcasm that also contributes to harshly striking out at and simultaneously concealing the true misery of existence. Man, in entirely distorted and inverted forms and attitudes, is the shadow of a degraded hero. But he preserves the traces of a hero even as they fade away. Of his giant athletic anatomy, there remains the spastic semblance of residual gestures of an ancient capacity to impress space with his own dynamic. Today, the Michelangelesque titan is a hero who dissolves and mingles with the material of the water closet on which he has collapsed. The origin of that image resides in a certain event that chance produced in the most vulnerable everyday occurrence of the individual. It is such a traumatic event as to become an obsession, impossible to close off in the private world and tragically inexorable in its agonizing projection over the same field, and almost amongst the same forms, that could proclaim a monumental entity in man, on which the divinity's forces could benevolently converge. But it is the Michelangelesque agitation of that same man and the simultaneous ascendance of his monument that transform his agony on the water closet into tragedy, his dissolution into indistinct matter.

In *Three Figures in a Room* (ills. pp. 56/57), the residues of lost, and now wounded, vitality are placed on an artificial plane, itself unreal and perfect, like a stage that coincides with the psychic extremes of the faculty of figuratively representing space and time. A horizon of the world within the limits of a room, on the contrary, in the room of individual life, which can be expressed only in the terms of pictorial form, incorporating real space as well as the artificial space of the three canvases comprising the triptych, abolishing all distinctions between the two conditions and restraining the continuity of its extension. In *Three Studies for Figures at the Base of a Crucifixion* of 1944 (ills. pp. 12/13), the figure brought along its own stools, spatial appendages that often pertain to its placement within a further articulation of the general space. With a variety of meanings, all subsequent paintings featured analogously abstract and frequently absurd conventions that transformed the figure's space into something similar to its conventional attribute, like the apparatus and proof of his aesthetic condition, its real identity as an element in a ritual representation. While this was his own shadow or a tangible structure on which they were hoisted up, as if on a support-

Three Studies for Portrait of George Dyer (on Light Ground), 1964
Oil on canvas, triptych, each panel 35.5 x 30.5 cm
Milan, Private Collection

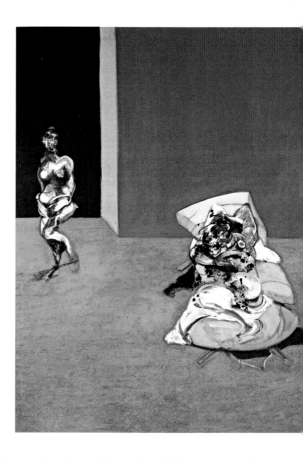

Crucifixion, 1965
Oil on canvas, triptych, each panel 198 x 147.5 cm
Munich, Staatsgalerie moderner Kunst

ing stool or an identifying mark, or the semblance of a tubular structure, or the sheets on a bed, this individual pertinence of placement in space could also contract and modulate itself as an objective form. Here, the plane is a vast oval area that unifies the three canvases, a chromatic but dense entity vested with a decisive scenic function. It is suspended in an abstraction of space that is entirely expressed in the difficult balance between the amber light of the surroundings and the ground plane of the shadow fluctuating in a lacerating extension.

The entire figure is agitated, rotating about itself, performing implausible acrobatic contortions, in poses and expressions beyond the limits of the ridiculous and expressive, entirely at the mercy of an unruly painting process. If the unknown element collapses with the fragile illusion of what is realistic, risking its own disappearance in the failure of the work, instead, in a successful painting it encounters a vaster and loftier mode of expression. Here the power of the figure resides in a complete assimilation of its poetic reference, a reference that is most profoundly connected with the truth of human events and the artistic history of man and his culture. The figure's humorously grotesque contractions ultimately reveal their dramatic and significant affinity with the tragic destiny and titanic content of the Michelangelesque figure that, simultaneously man and concept, rotates on its own axis, contorted by its own tension between form and formlessness, symbolically embodying the very breath of the flow of time and individual movement.

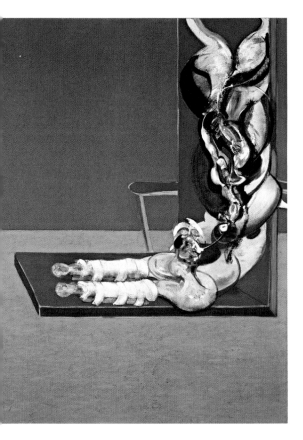

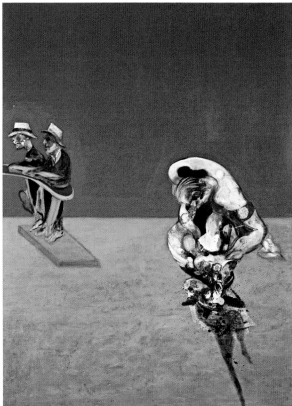

Bacon himself explained that he aspired to represent figures that would appear
real in the artificial isolation of pictorial space, just as normal people can appear
real in their daily conduct. Capturing these figures in that condition, he would
make them appear as excruciating as a Crucifixion. As a non-believer, Bacon
leaves the religious content of the Crucifixion explicitly out of consideration. At
the most rigorously concrete level, he considers it the image of a human act, an
extreme act that must be judged in the profane terms of an incident related to
human existence. In other words, something that regards man. It is not a mythi-
cal idea of man, considered, for example, as the image of a god, but man as a
complex animal, made of sense and matter. It is a profoundly real vision, capable
of embracing the entire significance of a sacred iconic tradition. This means
recognizing that civilization has concentrated its most sincere and agonizing
expression of pain in an image like the Crucifixion. This pain is manifested in
the agony of the flesh, its butchery, and the desperate cry of a life that is violently
torn from its natural organism. This image is instinctively assimilated in the
artist's fantasy with the butchery of an animal. Looming behind the monstrous
figure of *Painting 1946* (ill. p. 22) is a butchered carcass that owes its horrifying
majesty to syncretism with the image of crucified man in Christian art. Thanks
to the presence of the Crucifixion as one of the active elements of his poetic,
Bacon perceives the body as a vulnerable complex of carnal matter drenched by
torrents of blood. These precedents lend this drama of the devastation of a frag-
ile organism a resonance expressive of immense sentiments like the universal

tragedy of existence and human pity. For this reason the Christian myth of the Crucifixion excites his fantasy to the point of obsession, free of conditioning by cultural history and devotional sacredness (ills. pp. 10, 18/19, 25, 27 left, 29, 64, 66, 68). As defined by Bacon, it becomes a simple framework, revealing just how radical was his transformation of artistic motifs: "there have been so many great pictures in European Art of the Crucifixion that it's a magnificent armature on which you can hang all types of feeling and sensation … It may be unsatisfactory, but I haven't found another subject so far that has been as helpful for covering certain areas of human feeling and behaviour. Perhaps it is only because so many people have worked on this particular theme that it has created this armature – I can't think of a better way of saying it – on which one can operate all types of levels of feeling."

In *Three Studies for Figures at the Base of a Crucifixion* of 1944 (ills. pp. 12/13), Bacon had achieved a specific order of expression derived from a profound elaboration of iconographic tradition, in which he eliminated all references to crucified man. It was the theme of suffering people, the immobile and unstoppable release of anguishing pain, articulated in the triple icon transmitted to him by the history of art and assimilated with another archetype, isolated by the history of civilization with a similar power of combination: the furies of Greek tragedy, universal personifications and victims of the expression of vendetta (Bacon's specific source was Aeschylus).

The Crucifixion reappeared in 1965, and by means of its fully internalized treatment, he realized a new order in the expression of horror (ills. pp. 64/65). From the sedimentation of Crucifixion drama, he derived an original compositional structure, with its own dimension of symmetries and equilibrium. Here too, the background colors define an uninterrupted space that extends across the three canvases. Bare, distinct fields of pure color define an abstract and violent architecture of the psyche that does not describe any real environment, but rather a room of the unconscious, an artificial scene where the figures are ranged about in their particular identity and solitude. The artificial limit of the composition, the placement of the forms within the field of color, their distances and the rhythm of their relations compose the essential and exclusive action of their

Three Studies for a Crucifixion, 1962
Oil with sand on canvas, triptych, each panel
198.2 x 144.8 cm
New York, Solomon R. Guggenheim Museum

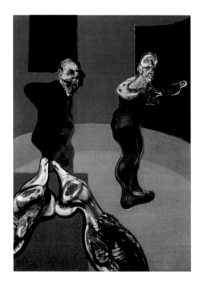
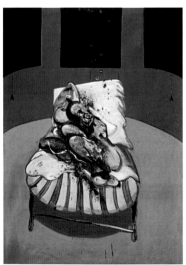
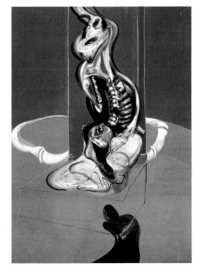

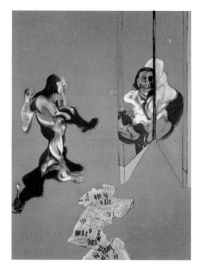 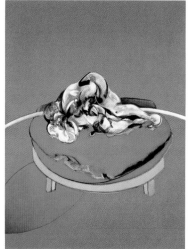 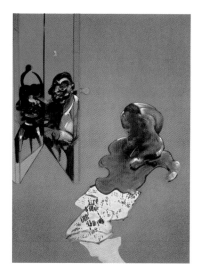

drama. Entirely played out within the abstract limits of the form, this action replaces any residual condition of naturalistic reality. What those figures represent is an examination overwhelmed at the roots by the same psychic impact that they provoke. Contemplation takes place at a level of perceptive alteration that disintegrates the logical condition of normalcy, emptying it of all predominance and depriving it of significance. All that remains is the inexorable course of a tragedy, whose obscurity with respect to the universal notoriety of the myth provokes dizziness and terror. Its enigma confronts the individual with the evidence of his own inanity, his own inability to dominate the rite, suspecting that the time and space of that unknown myth reside in the unknown subjectivity of the individual. So, it is understandable that the treatment of this subject in Bacon's works is increasingly internalized. The extreme juxtaposition of the figure with the condition of carnal matter and the hysterical explosion of his vulnerable psychology through the Crucifixion has an overwhelming impact. Finally, the subject and observer can communicate how they experience their own terror through the unknown universe that resides in them and renders even the most intimately personal experiences unknown and mysterious.

The sense of balanced measure, the sense of terror and the anguishing, omnipresent sense of comicality are indistinguishable. Of course this unpronounceable complex can take form only in painting. Then, the triptych is the scheme of catharsis, where the drama suffered in the blindness of conscience lets itself be represented and contemplated in the equilibrium of tragedy. But this balance is subject to the threat inherent in the exalted quality of colors and harmonies, in horror, which is even more disturbing when it affirms itself with forms of the highest aesthetic quality. It is as if beauty, which the work absurdly manages to recreate in all its various outcomes, were surrounded by the threat of obscure forces, the chaos just outside the triptych that was momentarily restrained by art and seemed to be on the point of regaining the upper hand.

Triptych – Studies from the Human Body, 1970
Oil on canvas, triptych, each panel 198 x 147.5 cm
Private Collection

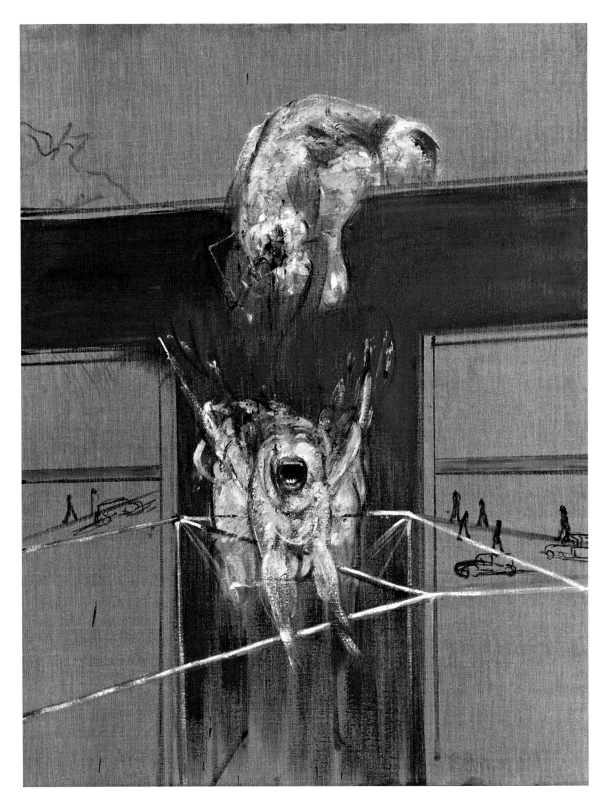

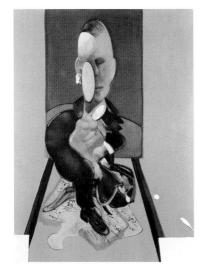 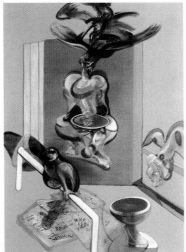 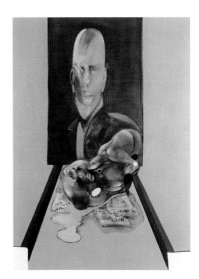

ILLUSTRATION PAGE 68:
Fragment of a Crucifixion, 1950
Oil and cotton on canvas, 139 x 108 cm
Eindhoven, Stedelijk Van Abbemuseum

Triptych, 1976
Oil and pastel on canvas, triptych, each panel
198 x 147.5 cm
Private Collection

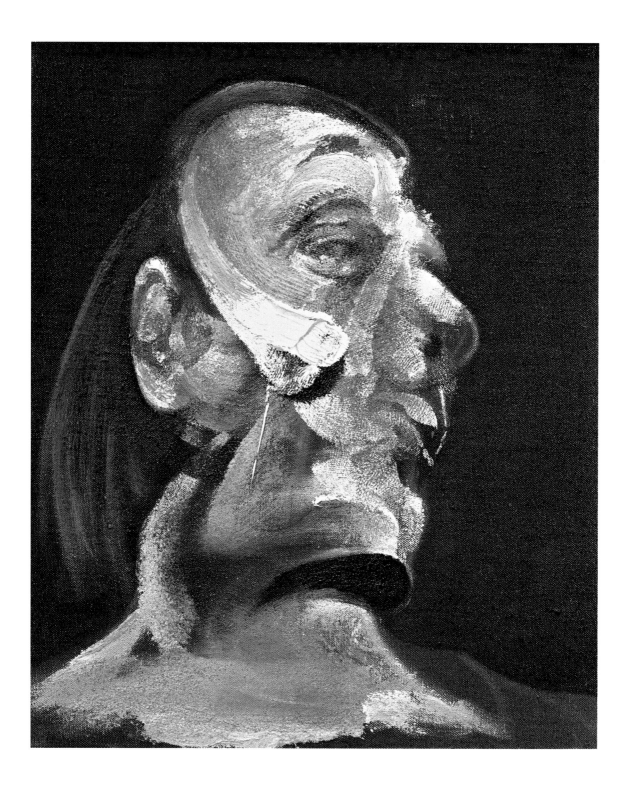

"The living quality"
Portraits

From at the beginning of the 1960s, Bacon confronted the problem of portraiture with a critical shift of his artistic exploration. Expression of the vitality of experience had led him to transfigure empirical reality into a reality of the most intimately true imagination of appearances. But his was a tireless and impatient search. At this point, he felt that any repetition of previously achieved formal conquests could become a cipher, that is, the repetition of a figurative trick, a reassuring habit that could re-evoke the danger of a conventional illustration. The danger was that overcoming existential experience in art might generate a generic image, consequently attenuating its emotional impact and relevance to reality. If the pictorial act magnifies sensation and liberates it from the accidental quality that conditions it, nevertheless the sensation must not lose its concreteness and may not become an abstraction. He then pushed his painting activity to higher levels, without hesitating to put it radically at risk, in order to come even closer to the figure and grasp it in a way still unknown to him. So, it is in a familiar person, with whom the most complex psychological implications of personal experience are bound up, that he sought the universe, the wickedness of life, the cosmic tragedy of existence. Then, to fix the impression of a particular person

Three Studies of Muriel Belcher, 1966
Oil on canvas, triptych, each panel 35.5 x 30.5 cm
Private Collection

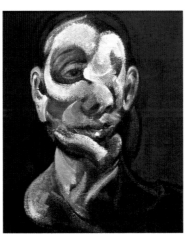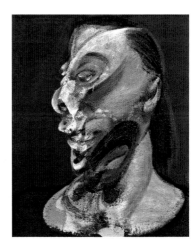

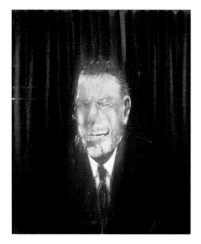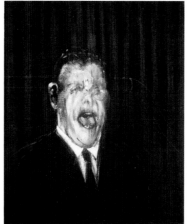

Three Studies of the Human Head, 1953
Oil on canvas, triptych, each panel 61 x 51 cm
Private Collection

whose specific identity is known, he investigates the part of the body that most characterizes the individual, the face. Pictorial expression became even more direct, more precisely penetrating. Bacon took the body and transformed it in the portrait, with the head becoming the face of a precise living being. Execution is a struggle: the entire work shows it, in continuous evolution. At this point, he confronted the head as the crucial place where, through the pictorial act, he could destroy, erase, and overturn the array of defenses that in normal life conceals and oppresses the real, instinctive and animal nature of being. When the repressed explosive energy of the person emerges in its expression, the head manages to become a portrait, to express the reality of the person. The common aspect of the face disappears, and the apparent wholeness of the personality disintegrates. Only fragments of it remain in the picture, little more than signs of belonging that concentrate its capacity for total, sudden, and violate identification.

In the *Three Studies of Muriel Belcher* of 1966 (ills. pp. 70/71) and the various triptych portraits with the same format that would follow from the 1960s until his death, Bacon radically transformed the expressive level of *Three Studies of the Human Head* (ills. p. 72). In that triptych, which had been fundamental and contained the germ of future developments, the relationship between the artist (destined to be replaced by the observer as soon as the work was completed) and the figure was governed by a precise relationship between distance and distinction. The figure was resolutely detached from the subject; indeed, it was almost imprisoned in a series of elements that were arbitrarily forged to identify and localize it. Now, the residual traces of such a system have been abandoned, as if dispersed in a fluid suppleness that confronts the expressive contrast from a traumatically internal level, as if additional and successive superstructures of the consciousness had been skipped and the painting aimed to penetrate a deeper and more obscure level of both the object and subject simultaneously, to the point of engaging the complex act of expression in the most sensitive quality of its execution.

The triptych establishes a rhythmic sequence of three images that evoke formulas of objective identification. The sequence opened by the head turned towards its own left, proceeding to the frontal pose in the center, and closed by the profile turned towards it own right is defined and articulated with a sche-

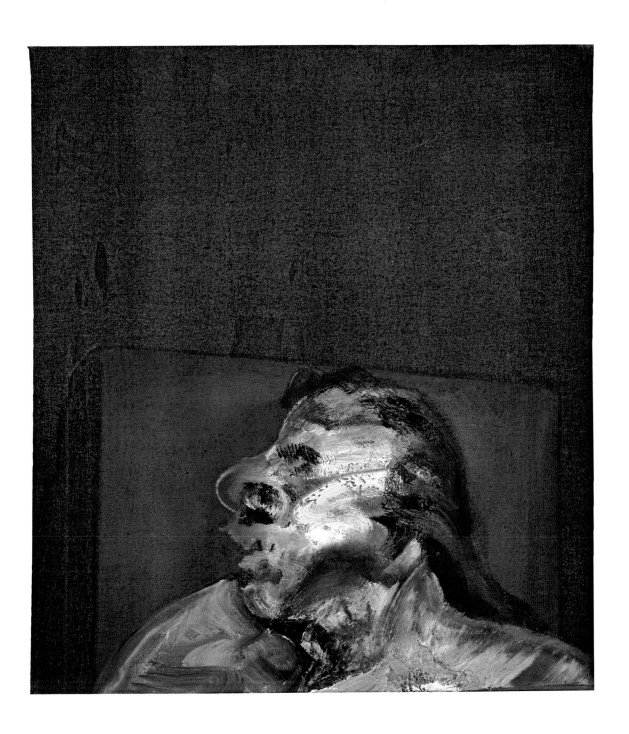

Miss Muriel Belcher, 1959
Oil on canvas, 74 x 67.5 cm
London, Ivor Braka Ltd.

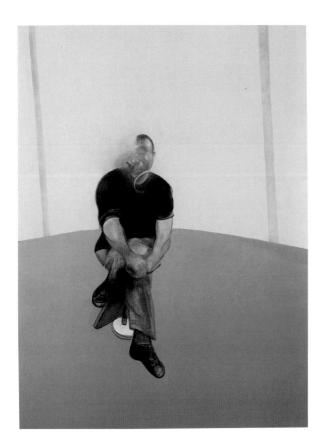
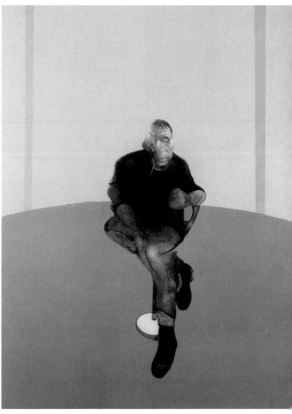

matic emphasis that has the feeling of a conventional procedure, almost as if it were a surreal legal or police identification process. Thus, the scheme, either through instinctive associations or through the iconology deriving from the triptych tradition, evokes the imposition of an authoritative order. Working against this conventional scheme, the pictorial execution exacerbates the most violent friction with the expression of the inner motion of the figure and unleashes the most reckless freedom of execution. It is in this friction that the appearance is disarticulated. The agitation manifested in the painting is concentrated in the rapidity of a few violent and decisive gestures on the quiet, smooth foundation of the background, which is tinted brown, burnt umber, and ruby red in the area dedicated to the figure. In the condensed revolution of its arrangement, it occupies only dissimilar parts of this prepared area and harmonizes with this chromatic context, which is almost preciously simplified. The form that emerges from the composition and handling of the chromatic material on the canvas in a series of blows, distortions, and erasures that are not prearranged but emerge in the experimental realization of a pictorial idea, expresses the strength, non-conformism, and provocativeness, and the generous, over-confident frankness of a vivid character: the truest features of the person represented. Gestures and rhythms that are almost impossible to define in the storm of brush marks restore the physiognomy of the painter's model with extraordinary liveliness. These are extremely sensitive impressions of physical characteristics, postures, and manners rendered in a way that is unmistakably similar to the other portraits of the

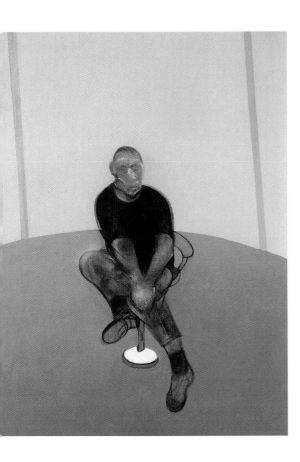

Study for Self-portrait – Triptych, 1985–1986
Oil on canvas, triptych, each panel 198 x 147.5 cm
Private Collection

same person executed by Bacon. All the portraits of Muriel Belcher restore the character of the figure with a vividness that no slavish or real imitation of the external forms of the subject's face and no photograph could have rendered with so much profundity and capacity for expression (ills. pp. 70/71, 73). The figure is expressed in all its humanity: the truest, because it corresponds to an individual reality, and yet no element accurately represents a real appearance. The entire concrete experience of knowing a human being, its manners, its reactions, how it moves and modulates its external features as a reflection of its internal forces, in short everything that fleeting concrete experience provides us about a known person is rendered in this work without the painting rigidifying the truth.

In *Study for Self-portrait*, the agitation of reality in the form and the capacity of painting to reveal the internal forces of the figure reach a more advanced level that is rendered more involving and truthful by its being a self-portrait. In this case the head's capacity to penetrate being engages the figure of the entire body. This painting represents the chronological and interpretative culmination of Bacon's various self-portraits, which were executed at different stages in the development of his pictorial style (ills. pp. 46, 89, 95). The figure's isolation, a constant need in his work, reaches the maximum degree of simplification in this triptych. Never had the figure touched the center of an individual's vitality as in these years, deriving from the tireless battle of erotic forces and their opposite. Concentrating this contrast on identity, especially one's own, reveals the essential

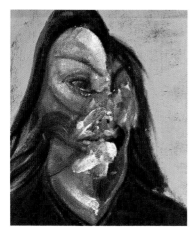 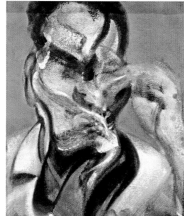 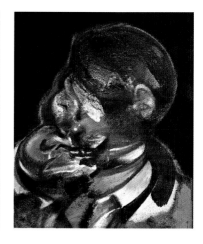

Three Studies for Portraits: Isabel Rawsthorne, Lucian Freud and J. H., 1966
Oil on canvas, triptych, each panel 35.5 x 30.5 cm
Private Collection

Study for Portrait of Isabel Rawsthorne, 1964
Oil on canvas, 198 x 147.5 cm
Private Collection

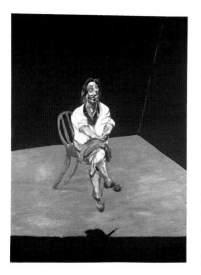

nature of the torment between vital desire and the sense of death, the basic material of existence. The monsters in *Three Studies for Figures at the Base of a Crucifixion* (ills. pp. 12/13) raised their cry isolated in a hue of unsustainable violence, perched on supporting structures that marked off their own unstable space. The entire development of Bacon's œuvre and this, his supreme final work, now show that that stool is a common chair, but this familiar object is still the arbitrary support of a profoundly unnatural situation that freezes the figure in a pose before it is transformed into expression through the painting. The figure is posing: it is disarmed, with all its vital energies exposed, without any support or protection. It is like the victim, the martyr of their internal struggle. The painting blocks all external motion and reveals the clash of infinite and unending internal revolutions. Once again, as in the heroic Michelangelesque figure, man reflects the action of his own upheaval at the same time as he undergoes its evolution. But the reason for this motion is the spasmodic inner movement revealed by the torment of an agitated, unstable, and uncomfortable pose. With heroic simplicity, this struggle resounds and upsets the man's miserable material and psychic vulnerability. And this man is grasped by the artist's brushwork in an implacable and sublime display of himself. The dissonant harmony of broad swathes of color represents the space of the man's solitude. Only the painting can express it, and even if the space is divided into three fields that are repeated according to the traditional triptych format, it does not limit the sensation of a measureless vastness. By imposing its own otherness on reality and rational logic, the force of the painting confirms that it is its own sole measure. There is no other standard of judgment, no key to interpretation other than what is inherent in art. The subject is shown calm in the expression of its own savage agitation. Here, Bacon's pity for humanity, which recurs in all his works, has the melancholy grandeur of a tragedy. The overwhelming struggle of the matter transpires in the most evanescent ways and ranges of hues. Its dissolution is now evaporation: the anguish of *Three Studies for Figures at the Base of a Crucifixion* is not resolved and has not lost its traumatic bluntness. It has evolved through a long series of different expressions, but it is the same quality that strikes the observer, with the same effect of reflecting something that totally involves him in its erotic agitation (even here, where there is no trace of sexual themes), its profound pity (even here, where there is no external motive).

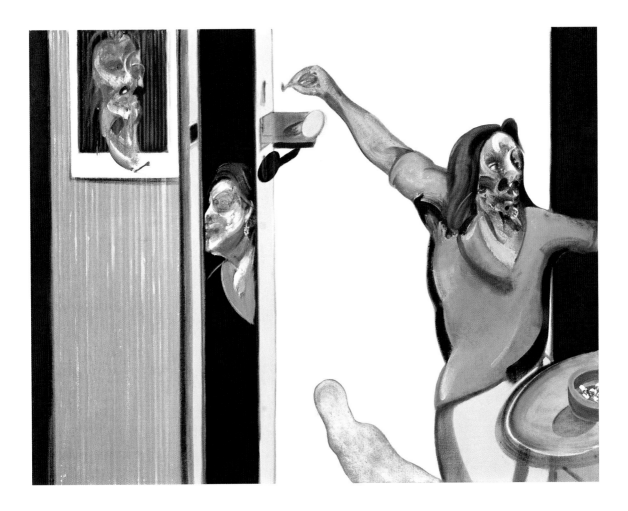

Three Studies of Isabel Rawsthorne, 1967
Oil on canvas, 119.5 x 152.5 cm
Berlin, Staatliche Museen zu Berlin –
Preußischer Kulturbesitz Nationalgalerie

Three Studies for Figures at the Base of a Crucifixion had manifested the resonance of a universal pain that burned all transitory references in this reference that might limit its expression to illustration of an accidental fact. What provoked the wail in that work was existence itself and the wound that it bears in its essential condition. Here the essential condition is defined in extreme detail as a condition of itself, of its own, deepest inner identity. The pictorial gesture is rapid, almost instantaneous in its self-manifestation, in its deforming quality, in the destruction of appearances. But the painting process imposes a desperately human and even caressing and lyrical expression. In the placid neutrality of the pose, in the model's attitude, ready to be transformed into an image, prepared for the inevitability of the artistic process, awaited with the sublimating rituality of martyrdom, rarefied nightmares emerge, signs of the terror and desperation exalted by the quiet of the visual beauty and succinct poetry of the harmonious colors. In the rending expression of pain and piety, the forms reverberate in an infinite extension of erotic sentiment and contemplation of death.

Bacon implicitly expressed this, albeit in the terse, technical terms that he used to explain the aesthetic principles of his painting: "The living quality is what you have to get. In painting a portrait the problem is to find a technique by

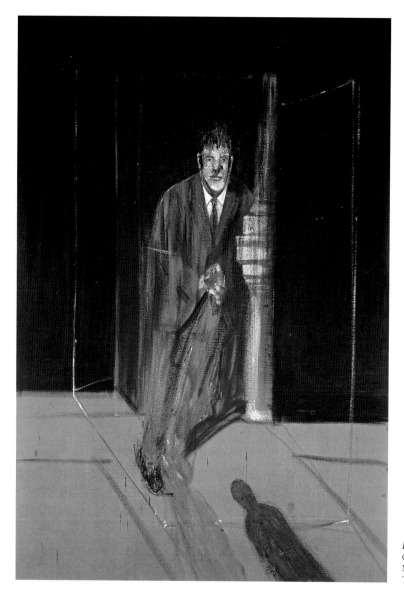

Portrait of Lucian Freud, 1951
Oil on canvas, 198 x 137 cm
Manchester, The Whitworth Art Gallery,
The University of Manchester

which you can give over all the pulsations of a person … The sitter is someone of flesh and blood and what has to be caught is their emanation … I don't know whether it would be possible to do a portrait of somebody just by making a gesture of them. So far it seems that if you are doing a portrait you have to record the face. But with their face you have to try and trap the energy that emanates from them."

Study for Self-portrait is one of the paintings that, in the most extreme way, permit us to recognize how in Bacon the work became the unifying link between the real world of existence and the subjective world. While no discipline or science of modern civilization can intimately comprehend or govern reality, the work expresses the existential discomfort of the individual and permits transformation of the subjective world into reality, to recognize oneself as a subject.

ILLUSTRATION PAGE 79:
Study of George Dyer in a Mirror, 1968
Oil on canvas, 198 x 147.5 cm
Madrid, Museo Thyssen-Bornemisza

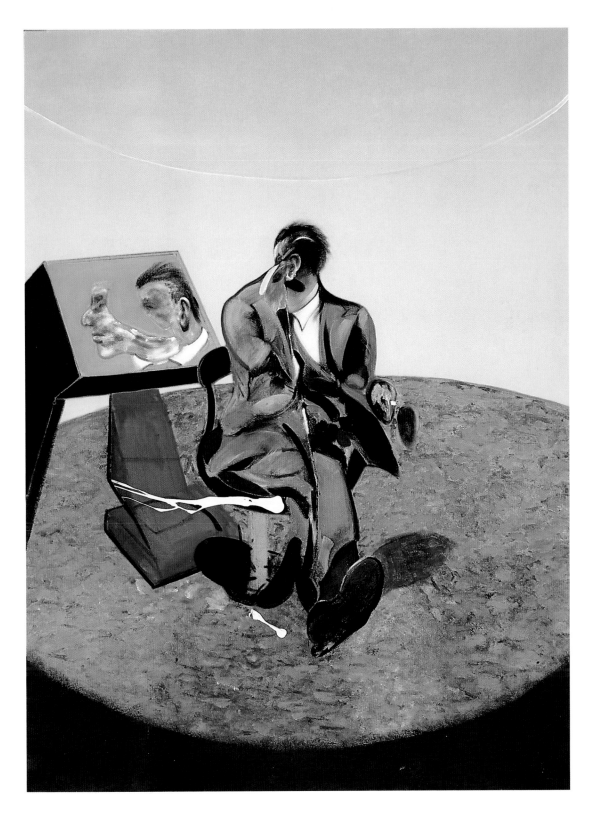

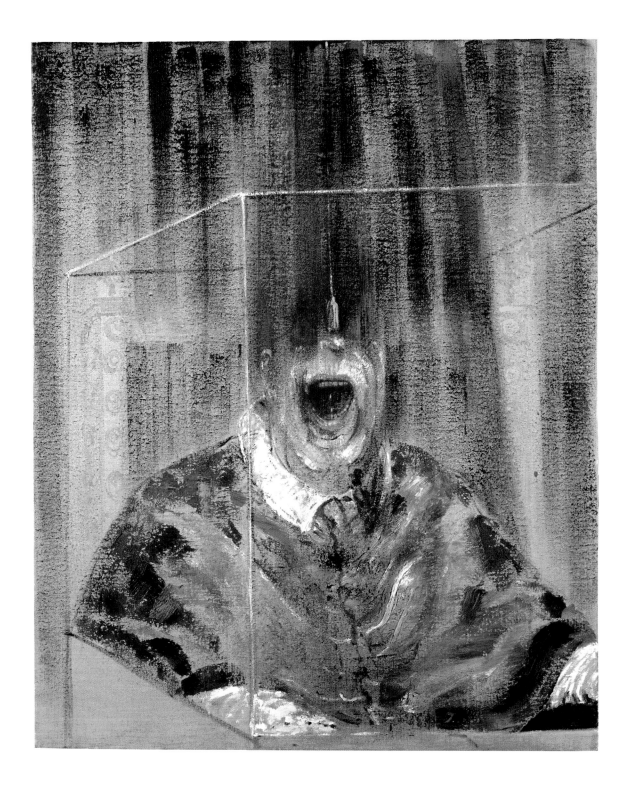

"I think of myself as a maker of images"
Sources of Inspiration

"… I think of myself as a maker of images. The image matters more than the beauty of the paint … I suppose I'm lucky in that images just drop in as if they were handed down to me … I always think of myself not so much as a painter but as a medium for accident and chance … I don't think I'm gifted; I just think I'm receptive …"

Bacon knew that the only way to grasp reality, what we have hitherto called lived experience and what was called "truth" at other times in history, is to transform shapeless masses of sensations into images and to lead this existential fact back to the two original impulses of human conduct: love – the power of erotic desire, generally called *eros* – and its opposite, death – the dissolution of desire and its motives, generally called *thanatos*. He felt that he had received infinite stimuli more or less consciously as images and absorbed them as such, although they were largely transformed or lost in the depths of consciousness. In order to recover awareness of them and through them touch something of the reality that has been lost in the meantime, these images must re-emerge. This cannot happen except through their radical recreation. Thus far, we have seen this process at work in exclusively basic terms – the purely artistic ones that Bacon himself considered relevant and what he agreed to talk about, while not devoting attention or giving importance to other circumstances, precisely because he wanted secondary aspects to remain just that. Nevertheless, if we take a glance at the materials he used, we can better understand the unparalleled rigor and qualitative level of his creative process.

There are myriads of sources that stimulated Francis Bacon's creative process. They were principally iconic sources: he collected them as potential stimuli. None of these sources represented a model for him, because painting is the most radical act of anti-authoritarian subversion that he knew and practiced, and thus did not permit the predominance of one model. However, they were stimuli for elaboration of the memory and the imagination. He kept innumerable fragments of the boundless multitude of chance images that had struck his receptive sensibilities (as he referred to his own nervous system) in one way or another, unconsciously. It is the material that can contribute to formation of the figure. This happens when the image emerges from the random and fragmentary quantitative mass and assumes a psychological insistence at the limits of obsession. In the course of painting, the source loses all internal references or capacity to

Study of a Figure in a Landscape, 1952
Oil on canvas, 198.1 x 137.7 cm
Washington DC, The Phillips Collection

ILLUSTRATION PAGE 80:
Head VI, 1949
Oil on canvas, 93.2 x 76.5 cm
London, Arts Council Collection,
Hayward Gallery

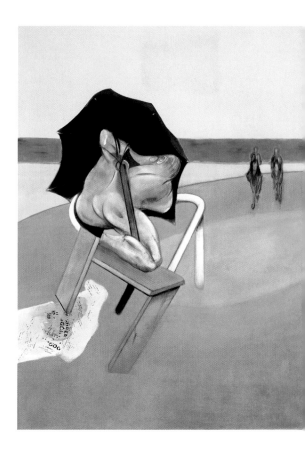

Triptych, 1974, revised 1977
Oil and pastel on canvas, triptych,
each panel 198 x 147.5 cm
Private Collection

describe an origin or real stimulus, to illustrate a precise intent. What remains is an image that depends on a stimulus that has partially objective and partially psychic origins. But, it is so suspended as not to permit any logical recomposition, description, or narrative and thus does not permit the formation of any meaning with an external nature.

Bacon surrounded himself with a multitude of photographic reproductions cut out of periodicals or torn from books or illustrated books on art or science, such as medicine and anthropology. Most of them are worn-out images that are frequently torn, abraded, and stained, tattered from use in his painting activity. As reproductions from many different technical categories and kinds of publications, they represent a chaotic universe of iconic stimuli. They cover every corner of his studio, recreating the limitless flow of quantity that is characteristic of photography. Reproductions of images clash and overlap everywhere, exasperatedly illustrating the inner condition of a search for permanent imbalance and revolution on the physical and psychological level.

During Bacon's lifetime, the condition of his working space – his working method – was known to just a few, rare individuals who were admitted into the intimate sphere of his life. At the time, the original and rigorous hierarchy of values that Bacon imposed on assessment of the components of his art prevented them from being overrated. Nevertheless, after his death, all the material in his studio has become the object of reflection, as is normal in the gradual modification of orientations towards historicizing an artist's work. Now, meticulous

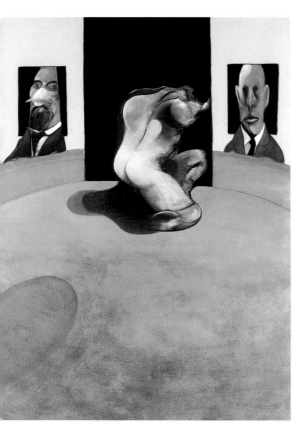

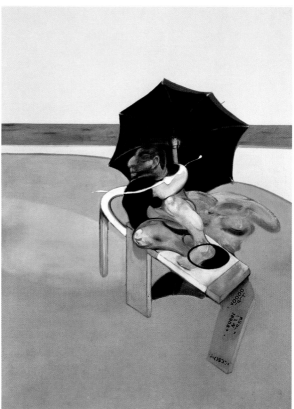

analysis of the iconic sources that composed the chaos of his studio has shown that many of the photographs in Bacon's creative space furnished him with the figurative material from which his pictorial images were created. Most of the images in his paintings derive from instant photographs of lovers or photographic portraits of acquaintances or himself. Others come from a fundamental source, the photographic research of Edward Muybridge, who worked during the last quarter of the 19th century. Yet others came from photos found in periodicals.

It is clear that for Bacon photography was the most appropriate technique to capture reality and prevent it from escaping, even if it escapes instead from sensible perception. But photography, thanks to its ability to interrupt the continuous flow of the visible by cruel artifice, is also the ideal technique for obtaining an extended iconic fragmentation. Bacon is fascinated by the ability of the photograph to produce innumerable images that are potentially foreign to any logical or discursive reference. Existential experience is not realized through the eyes but through all the senses, and the eye drowns in the ambiguity provoked by the convoluted simultaneity of the senses and superimposition of the different systems of relationship that they involve. The eye must be given help to see. Photography, which is foreign to the dynamics of any sense system, but strongly influential on perception thanks to its particular nature, can reiterate the emotion of events or sensations experienced in existential reality. It can furnish an image that can in turn provoke movement of the sensations present in the deep sub-rational consciousness of man.

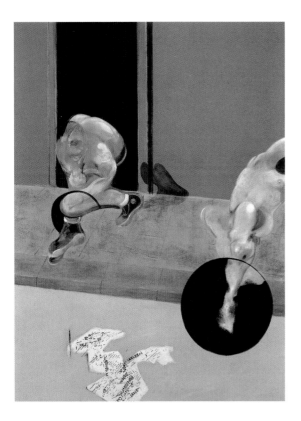

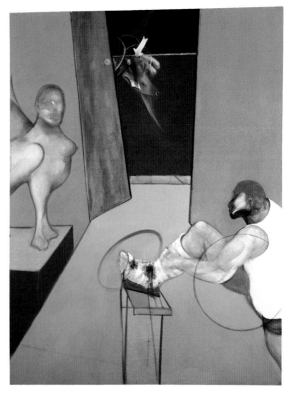

Then Bacon perceives the photographic image as something incomparably simpler and more superficial than the artistic image, for example, the pictorial image. He considers it an external recording of what is apparent, not something that depends on a profound operation that requires talent and technique. For these reasons, photography strikes him as being a system of representation that is more subject to chance and thus can be more easily manipulated and neutralized, as well as more amenable to free associations. In the process of decontextualization, elements deriving from a photographic source are more easily permeated with new meanings, such as the exclusively formal meanings of the artistic image, while preserving something of their origins.

With these characteristics of neutralization, the photograph can deprive the real, reproduced subject of its reality and stimulate the observer's spirit in an unforeseen and often incongruous way that pertains only partially to the actual object. What Bacon most liked about the photograph was its "fluidity of surface," its limit, its inability "to get under the surface of things."

Symptomatic of this function is how much he reveals about the emotional effect exercised on him without any specific reason by photographs of slaughter houses, butchered meat, and animals about to have their throats slit, and how these are associated in his fantasy with his sense of the Crucifixion. In practice, he seeks an image of what is real in photography, of man and things, that is free of conventions, and how the mechanical and accidental interruption not only of movement but also the continuity of the relationships and reasons of things and actions can produce it.

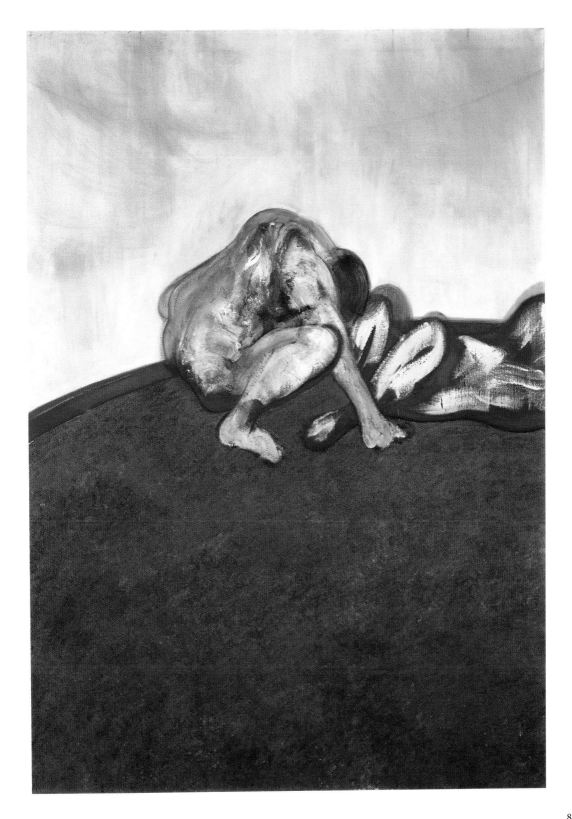

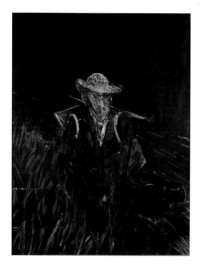

Study for a Portrait of van Gogh I, 1956
Oil on canvas, 152.5 x 117 cm
Norwich, University of East Anglia,
Collection Robert and Lisa Sainsbury

Incongruously interrupting the continuity of reality, photography can provoke the artificial arrangement of the figure in a condition of extreme agitation, ridiculous inanity, and pitiful misery. It can reveal its tragic unnaturalness, with unusual and unreal features that are hyper-real at the same time, too true to be sustainable by rational analysis but rendered absolutely truthful in consequence of its emotional plainness, and thus capable of assuming an absurd, irrational, and surreal truth.

Scientific photography, realized in the form of gymnastic or clinical images like those found in Muybridge's studies or X-rays of the human body, illustrates the figure's point of vulnerability. It is through those methods of photographic recording or the medical circumstances of the X-rays that man's mechanics are more exposed and defenseless, just as in love. Muybridge's attraction for research lead him to associate photographs of human movement with photographs of animal movement, providing him with external material that is highly evocative and ductile in giving form to that sensation of intermingling of the human and animal that he feels is emerging at times in man and at times in the animal when either one or the other becomes the subject of a painting. It is this intermingling of the two elements, in its becoming a pictorial subject, that provokes the effect of profound pity for the figure.

But in Bacon, photography is not just the means for haphazardly accumulating external recordings of apparent reality. Amidst the chaos of his studio we also find reproductions taken from art books and monographs on artists of the past. In this case, photography captures his attention with complete and intentional force because it reproduces images that in Bacon's eyes are of a completely different type. In his case they consist of images vested with the greatest profundity, true interpretations of subjective reality – of the same sort as what awaits him, as artist, at the conclusion of the painting process. Even if his direct awareness of works of art was vast, he nevertheless preferred to use photographic reproductions of a work rather than refer to the original in order to achieve the assimilation that would transform it into an intermediate reference between objectivity and the unconscious. From the inventive quality of his references to the art of the past, it is clear how profoundly Bacon had understood various elements of the work of Michelangelo or Velázquez or Van Gogh or Degas or Soutine; how complex, lasting, and variable the development of his attraction for Picasso was over time; how conscious and profound his understanding of Cézanne's work was.

What he drew from the works of other artists were key aspects of what he defined as "the mystery of painting" and what he specifically identified in the all-consuming experience of execution, as we have seen. "To me the mystery of painting today is how can appearance be made. I know it can be illustrated. I know it can be photographed. But how can this thing be made so that you catch the mystery of appearance within the mystery of the making." This aspect is exactly the opposite of the accidental recording represented by photography, which is just as fortuitous, contrasting, and unforeseeable as the appearance of reality. What takes place during the execution of his works is the profound struggle between these two terms. This is why the sensations of experience can pass through Muybridge's studies of the movements of the human body or animals, assimilate themselves with the forms of Michelangelo Buonarroti, and ultimately express the figure of his love, pitifully agonizing and human.

ILLUSTRATION PAGE 87:
Sand Dune, 1983
Oil and pastel on canvas, 198 x 147.5 cm
Riehen/Basel, Fondation Beyeler

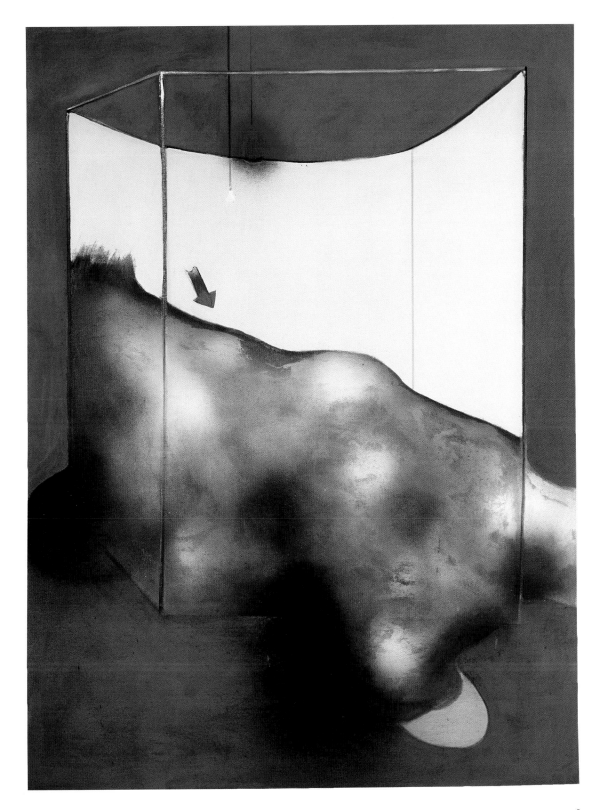

Biography
Francis Bacon 1909–1992

1909 Francis Bacon, the second of five children, was born in Dublin on October 28. His father, Edward, was an authoritarian and violent man who became a horse trainer after retiring from the military. His mother, Winifred, twenty years younger than her husband, was sociable, educated, and blessed with a light and bubbly spirit.

1914 Upon the outbreak of war, the family moved to London after Bacon's father received an appointment to the War Office. The family's continuous moves between England and Ireland over the following ten years, combined with the chronic asthma that would plague him throughout his life, severely conditioned his childhood, preventing him from receiving a complete and regular education. He grew up under relatively undisciplined and solitary circumstances, punctuated by occasional visits to his maternal relatives, whose eccentric and joyous lifestyle exerted a powerful influence on him.

1925 During his adolescence, he acknowledged his homosexuality, further complicating his life. When he was sixteen, his father found him wearing his mother's undergarments and threw him out of the house. Francis went to live alone in London under forced circumstances, working at one temporary job after another to survive and fully dedicating himself to the pleasures of life.

1927–1928 In an extreme attempt to save his son from a libertine and dissolute way of life, his father sent him to Berlin in spring 1927, accompanied by an uncle. In point of fact, his uncle's supervision was utterly ineffectual, with Francis taking advantage of the situation by plunging headlong into the joyous vitality of the city. Two months later, he arrived alone in Paris.

He enthusiastically learned the French language, painted, and made a living by doing jobs as interior decorator and designer. In July 1927 he visited the exhibition of recent works by Picasso at Paul Rosenberg's gallery, which profoundly moved him.

1928 He returned to London, and in the following year set up a studio in a garage at Queensberry Mews West, South Kensington, where he lived and worked from 1929 to 1932. He designed furniture and rugs in the modernist style, and also painted in close collab-

ILLUSTRATION LEFT:
Furniture and rugs designed by Bacon, photographed in his studio, 1930

ILLUSTRATION PAGE 89:
Self-portrait, 1973
Oil on canvas, 198 x 147.5 cm
Private Collection

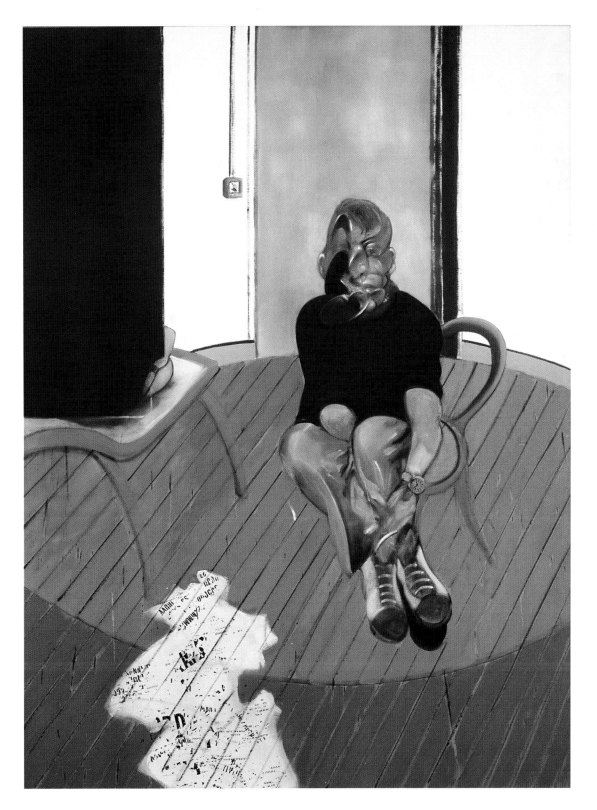

oration with the post-Cubist Australian painter Roy de Maistre, who introduced him to the technique of painting, guiding his study of the art.

1930 The August 1930 issue of the journal *The Studio* featured his tapestries, rugs, and steel and glass furniture in a survey of 1930s English interior design style (ill. p. 88). He organized an exhibition in his studio in November, presenting his paintings, a print, and four tapestries together with works by Roy de Maistre and the portraitist Jean Shepeard. The exhibition was greeted by total indifference, and Bacon abandoned his design and painting work.

1931 He went to live on Fulham Road and, discouraged by his failure, with-

drew into his private life. He took on odd jobs to make ends meet.

1933 At the "Art Now" exhibition held at the Mayor Gallery in London, the most important gallery for the avant-garde in England at that time, he exhibited *Crucifixion*, which Herbert Read reproduced in his book *Art Now: An Introduction to the Theory of Modern Painting and Sculpture*, published for the occasion. The eminent modern art collector Michael Sadler bought the painting and commissioned two other crucifixions in the same vein.

1934 He held his first one-man show in February, exhibiting seven oil paintings and six gouaches in the space that the interior decorator Arundell Clarke, his admirer, opened up to artists in his

personal residence on Curzon Street, with the extemporaneous name "The Transition Gallery." The partial failure of the exhibition led him to abandon painting once again and destroy many of his works.

1936 His pessimism over his bad luck as artist and dissatisfaction with his own paintings were aggravated when he was left out of the "International Surrealist Exhibition" in 1936, although this was justified by the strictly historical interpretation of the term and the diversity of Bacon's poetic with respect to the Surrealist movement.

1937 Eric Hall, a man of taste, one of his first supporters, and also his lover for several years, organized the group show "Young British Painters" in the refined and important antique gallery Agnew's, where Bacon exhibited *Figures in a Garden* (ill. p. 14), one of the rare paintings to have survived from that period. It is a masterpiece that reveals his innovative genius, inspired by Picasso and Matisse.

1941–1943 Exempted from military service due to his asthma, he was assigned to service in the civil defense rescue corps during the war. He resided for a certain time in a rented cottage together with Erich Hall at Petersfield in Hampshire. Upon returning to London at the end of 1942, he took up residence on the ground floor of 7 Cromwell Place, South Kensington, in the home of John

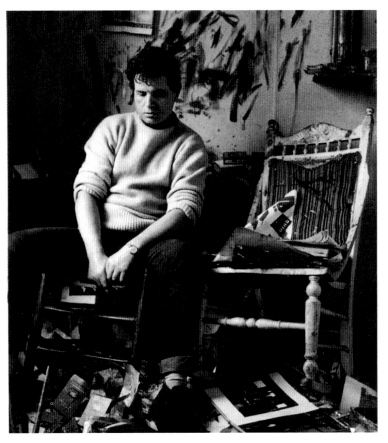

ILLUSTRATION LEFT:
Bacon in his studio, late 1950s

ILLUSTRATION PAGE 91:
Francis Bacon with George Dyer, c. 1960

gambling and lived until 1950, with intermittent stays in London.

1949 The series of six *Heads* (ills. pp. 10, 80) dates from this year, and the pope's image from the *Portrait of Innocent X* by Velázquez appears in one of them, *Head VI*, for the first time, as well as the ape motif. In November, he exhibited his monochromatic canvases at the Hanover Gallery, in a show organized by Erica Brausen, who in the meantime had become his agent and resold his *Painting 1946* (ill. p. 22) in 1948 to Alfred Barr for the Museum of Modern Art in New York.

1950–1951 After returning for good to London, he taught for several months at the Royal College of Art in London, substituting for his friend John Minton. Between 1950 and 1951, he developed the theme of the pope in two series of paintings, taking Velázquez as his starting point (ill. p. 38). In a one-man show at the Hanover Gallery at the end of 1951, he presented three paintings from the *Pope* series. Upset by the death of his friend Nanny Lightfoot, he hurriedly sold his studio at Cromwell Place, leaving various paintings unfinished. Over the next ten years, he worked in temporary studios. In 1951, he painted the first *Portrait of Lucian Freud* (ill. p. 78).

Everett Millais, which also housed a billiards parlor.

1944–1945 He wholeheartedly threw himself back into painting. He considered this time to be the true beginning of his art and started protecting his works against the destruction wrought by his own dissatisfaction in previous years. In 1944, he painted the triptych *Three Studies for Figures at the Base of a Crucifixion* (ills. pp. 12/13), which he exhibited in April 1945 at the Lefevre Gallery. This exhibition deeply upset visitors, provoking heated arguments. Using a photograph of Eric Hall dozing on a bench in Hyde Park, he exe-

cuted *Figure in a Landscape* (ill. p. 20) in 1945.

1946 He participated in various group shows at the Lefevre Gallery, Redfern Gallery, and Anglo French Art Centre. The paintings dating from this period, such as *Figure Study I* and *II* (ills. pp. 15, 21 top), provoked violent reactions and rare, but enthusiastic support. Encouraged by Graham Sutherland, the immigrant German art dealer Erica Brausen visited his studio and paid £200 on the spot for his masterpiece *Painting 1946* (ill. p. 22). Thanks to this windfall, he left for Monte Carlo, where he indulged in his passion for

1952 Between 1951 and 1952, he executed a series of paintings based on the crouching nude theme (ills. pp. 37, 43) that evolved with the inclusion of a naturalistic element (ill. p. 39 left), which in turn gave rise to several landscape paintings, inspired by van Gogh and his feelings for the south of France (ill. p. 81). These works were exhibited at the Hanover Gallery together with the landscapes inspired by trips to Africa: in South Africa, where his mother and sisters lived, and in Kenya. He met Peter Lacy, with whom he started a long and tormented rela-

tionship, during which time they sojourned on various occasions in Tangiers. Eric Hall purchased *Dog* and donated it to the Tate Gallery.

1953 He worked intensively on the portraits in *Three Studies of the Human Head* (ill. p. 72) and on the series *Study for Portrait*, again based on the figure of Pope Innocent X by Velázquez (ills. pp. 24, 26). Several paintings from this latter series were exhibited at his first one-man show abroad, at Durlacher Brothers in New York. Eric Hall donated *Three Studies for Figures at the Base of a Crucifixion* (ills. pp. 12/13) at the Tate Gallery. He painted *Two Figures* (ill. p. 47), based on a Muybridge photograph of wrestlers who take the form of Bacon himself and Peter Lacy in the new work.

1954 Seven canvases survive from

the *Man in Blue* series exhibited at the Hanover Gallery (ill. p. 44). Together with Ben Nicholson and Lucian Freud, he represented Great Britain at the pavilion curated by David Sylvester at the 27th Venice Biennale. He made a trip to Rome, where he significantly failed to view the original version of *Innocent X* by Velázquez.

1955 The Institute of Contemporary Arts organized the first retrospective of Bacon's work, in London. In May he participated in a group show at the Museum of Modern Art in New York. New York. At the Hanover Gallery he exhibited a series of portraits based on the cast of William Blake's head at the National Portrait Gallery. He painted the portraits of his collectors and close friends Robert and Lisa Sainsbury.

1956 In 1956–1957 he did a series of paintings inspired by reproductions

of the *Painter on the Tarascon Road* by van Gogh, which had been destroyed in Germany during World War II. He joined Peter Lacy in Tangiers, where he rented an apartment that would be used for repeated stays until the early 1960s. There he frequented the company of William Burroughs, Paul Bowles, Allen Ginsberg, and the young Moroccan artist Ahmed Yacoubi.

1957 Erica Brausen organized his first one-man show in Paris at the Galerie Rive Droite, managed by Jean Larcade, where he presented his most recent work, including some from the series *Study for a Portrait of van Gogh* (ill. p. 86), subsequently exhibited at the Hanover Gallery.

1958 In 1958 he exhibited for the first time in Italy: a retrospective at the Galleria Galatea in Turin, then at the Galleria dell'Ariete in Milan, and fi-

nally at the Galleria dell'Obelisco in Rome. He was chosen to represent Great Britain at the Carnegie Institute in Pittsburgh. He ended his relationship with Erica Brausen and the Hanover Gallery and signed an agreement with the Marlborough Fine Art Gallery.

1959 He participated in documenta II at Kassel and the 5th Biennial in São Paulo. He executed the portrait of Muriel Belcher, operator of the Colony, his favorite bar in Soho (ill. p. 73). Eric Hall died.

1960–1961 He held his first one-man show at the Marlborough Fine Art Gallery, exhibiting thirty of his most recent works. In 1961 he set up his studio in a garage at Reece Mews, South Kensington, which became the permanent base for his work. Here he found the space most suited to recreating the chaos that he needed to work.

1962 First big retrospective at the Tate Gallery, covering almost half of his painting output, up to the first grand triptych *Three Studies for a Crucifixion* (ills. p. 66), which was purchased by the Guggenheim Museum in New

York. The exhibition then traveled to Mannheim, Turin, Zurich, and Amsterdam. On the eve of the show opening in London, he received word of Peter Lacy's death in Tangiers.

1963 He started a relationship with George Dyer, who would become a favorite source of inspiration for him. The Guggenheim of New York dedicated an important retrospective to him, which then traveled to the Art Institute of Chicago.

1964–1965 He painted the triptychs *Three Figures in a Room* (ills. pp. 56/57), which were acquired by the Musée National d'Art Moderne in Paris and, in the following year, *Crucifixion* (ills. pp. 64/65), acquired by the Staatsgalerie Moderner Kunst in Munich. He started working on the figure of Isabel Rawsthorne, who became the subject of different portraits in the following years (ills. pp. 74–77). In 1964 Ronald Alley published a catalogue raisonné of his work, with a preface by John Rothenstein, Director of the Tate Gallery. In the same year, John Russell's monograph was published. In 1965, he met Michel Leiris at the opening of the Giacometti show at the Tate

Gallery and initiated a close friendship with him.

1966–1967 Maeght in Paris and Toninelli in Milan dedicated one-man shows to him. In 1966 he received two important international awards, the Carnegie Institute Award (Pittsburgh), which he refused, and the Rubens Prize (Siegen), which he donated for restoration of art works damaged during the flood in Florence that year.

1968 He traveled to New York for the first time for the opening of his show at the Marlborough Gallery (the twenty paintings on exhibit were all sold in the first week). The Hirshhorn Foundation of Washington acquired the *Triptych Inspired by T. S. Eliot's Poem "Sweeney Agonistes"* (ills. pp. 40/41).

1971 The big retrospective opened in October at the Grand Palais in Paris, which exhibited more than one hundred paintings and eleven large triptychs. On the eve of the opening, George Dyer was found dead in his hotel room. In November and December he painted the triptych *In Memory of George Dyer* (ills. pp. 60/61). His fig-

ure and the image of his death recur in many of his subsequent paintings (ills. pp. 32, 48/49, 62).

1974 In 1974 he started a close, paternal relationship with John Edwards, whom he depicted in numerous paintings and who later became his heir.

1975 He traveled to New York for the opening of his one-man show of recent paintings at the Metropolitan Museum, curated by Henry Geldzahler. He met Andy Warhol. The *Interviews with Francis Bacon* by David Sylvester were published. He stayed in Paris, in an apartment on the Place des Vosges that he would periodically use until 1985 for sojourns and painting.

1976 He traveled to Marseilles for the opening of his exhibition at the Musée Cantini.

1977 In January, he held a one-man show at the Claude Bernard gallery in Paris. In October he exhibited at the Museo de Arte Moderno in Mexico City.

1978 He visited Rome, where he met Balthus at Villa Medici. He exhibited

in Spain, in Madrid and Barcelona. During these years, he continued to work intensively on the portrait and self-portrait motifs.

1979 Death of Muriel Belcher, one of his dearest friends and the subject of various portraits (ills. pp. 70/71, 73).

1980 He exhibited recent works at the Marlborough Gallery in New York.

1981–1983 He painted the *Triptych Inspired by the Oresteia of Aeschylus* (ills. pp. 16/17). Two important interpretations of his work by French critics were published: the essay "Bacon le hors-la-loi" by Michel Leiris and "Logique de la sensation" by Gilles Deleuze. Leiris's subsequent essay *Francis Bacon: Full Face and in Profile* was published in 1983.

1984 He participated at the opening of exhibitions at the Galerie Maeght Lelong in Paris and the Marlborough Gallery in New York.

1985–1986 Second big retrospective of his work organized by the Tate Gallery, which subsequently traveled to Stuttgart and East Berlin. On this occasion,

he returned to Berlin for the first time since his stay in 1926, accompanied by John Edwards.

1987 His recent works were shown at the Galerie Lelong in Paris and the Galerie Beyeler in Basel.

1988 An exhibition of some of his works was held at the New Tretyakov Gallery in Moscow. He painted the *Second Version of "Triptych 1944"* (ills. pp. 18/19), which was exhibited the year after in the show "New Paintings Bacon, Auerbach, Kitaj" at Marlborough Fine Art in London.

1990 Trip to Madrid to visit the Velázquez exhibition at the Prado. Michel Leiris died.

1992 Bacon died of a heart attack in Madrid on April 28. He willed his estate to John Edwards, who donated the studio at Reece Mews where he had painted all his works between 1961 and 1992, as well as its entire contents, to the Hugh Lane Municipal Gallery of Modern Art in Dublin. The studio was opened to the public in 2000 after reconstruction.

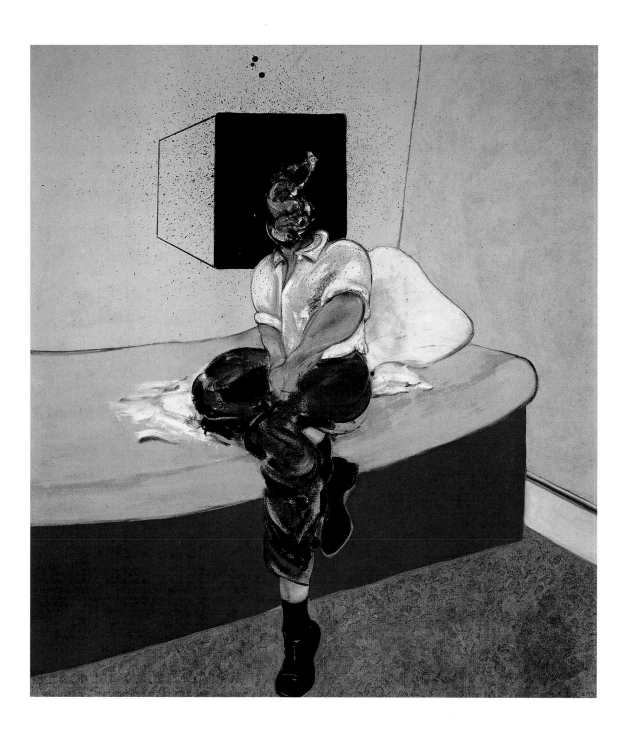

Study for Self-portrait, 1964
Oil on canvas, 155 x 140 cm
London, Richard Nagy Fine Art

Selected Bibliography

Alley, Ronald and John Rothenstein: *Francis Bacon*. Exhibition catalogue. London, Tate Gallery, London 1962.

Alley, Ronald and John Rothenstein: *Francis Bacon*. London and New York 1964.

Archimbaud, Michel: *Francis Bacon: entretiens avec Michel Archimbaud*. Paris 1992.

Davies, Hugh and Sally Yard: *Bacon*. New York and London 1986.

Deleuze, Gilles: *Francis Bacon: Logique de la sensation*. Paris 2002.

Farr, Dennis et al.: *Francis Bacon. A Retrospective Exhibition*. Exhibition catalogue, New York 1999.

Figurabile. Francis Bacon. Exhibition catalogue (essays by David Sylvester, David Mellor, Gilles Deleuze, Lorenza Trucchi, Daniela Palazzoli), XLV Biennale di Venezia, Museo Correr, 1993.

Francis Bacon. Exhibition catalogue (introduction by Michel Leiris). Paris, Galeries Nationales du Grand Palais, 1972.

Francis Bacon: Recent Paintings 1968–1974. Exhibition catalogue (introduction by Henry Geldzahler, with a contribution from Peter Beard). New York, The Metropolitan Museum of Art, 1975.

Francis Bacon. Exhibition catalogue (essays by Down Ades, Andrew Forge, Andrew Durham). London, Tate Gallery, 1985.

Francis Bacon, Exhibition catalogue (essays by Ronald Alley, Hugh M. Davies, Michael Peppiatt, Rudy Chiappini. Catalogue by Jill Lloyd and Michael Peppiatt). Lugano, Museo d'Arte Moderna di Lugano, 1993.

Francis Bacon. Important Paintings from the Estate (essays by David Sylvester, Sa Hunter and Michael Peppiatt). New York, Tony Shafrazi Gallery, 1998.

Francis Bacon: Caged – Uncaged. Exhibition catalogue (essay by Martin Harrison and introduction by Vicente Todoli). Porto, Museu Serralves, 2003.

Herrgott, Fabrice: *Francis Bacon*. Exhibition catalogue. Paris, Centre Georges Pompidou, 1996.

Leiris, Michel: *Francis Bacon ou la vérité criante*. Paris 1974.

Leiris, Michel: "Bacon le hors-la-loi", in: *Critique*, May 1981.

Leiris, Michel: *Francis Bacon: Full Face and in Profile*. London 1983.

Leiris, Michel: *Francis Bacon*. London 1988.

Peppiatt, Michael: "From a conversation with Francis Bacon", in: *Cambridge Opinion* 37, January 1964.

Peppiatt, Michael: "Francis Bacon: Reality Conveyed by a Lie", in: *Art International*, I: Autumn, 1987.

Peppiatt, Michael: "Six New Masters", in: *Connoisseur* 217, September, 1987.

Peppiatt, Michael: *Francis Bacon: Anatomy of an Enigma*. London 1996, New York 1997.

Rothenstein, John: *Francis Bacon*. Milan 1963.

Russell, John: *Francis Bacon*. New York 1993.

Schmied, Wieland: *Francis Bacon. Commitment and Conflict*. Munich, New York 1996.

Sylvester, David: *Interviews with Francis Bacon*. London 1995.

Sylvester, David: *Looking back at Francis Bacon*. New York 2000.

Trucchi, Lorenza: *Francis Bacon*. Milan 1975.

Zimmerman, Jörg: *Francis Bacon. Kreuzigung*. Frankfurt am Main 1986.

Photo Credits